THE ART OF MINDFULNESS

HAPPY AND ENERGIZED COLORING

LARK

New York

LARK

New York

An Imprint of Sterling Publishing
1166 Avenue of the Americas
New York, NY 10036

LARK CRAFTS and the distinctive Lark logo are registered
trademarks of Sterling Publishing Co., Inc.

First published in the United Kingdom in 2015 by Michael O'Mara Books Ltd., as
The Art of Mindfulness: Happy and Energized Colouring

© 2015 by Michael O'Mara Books Ltd.

Designed by Ana Bjezancevic and Claire Cater
Cover illustration by Pimlada Phuapradit

Illustrations by Amanda Hillier, Angelika Scundamore, Anna Shuttlewood, Claire Cater,
Faye Buckingham, Jo Taylor, Julie Ingram, Katrin Alt, Louise Wright,
Pimlada Phuapradit, and Sam Loman

ISBN 978-1-4547-0959-6

Distributed in Canada by Sterling Publishing
c/o Canadian Manda Group, 664 Annette Street
Toronto, Ontario, Canada M6S 2C8

For information about custom editions, special sales, and premium and corporate purchases,
please contact Sterling Special Sales at 800-805-5489 or specialsales@sterlingpublishing.com.

Manufactured in Canada

4 6 8 10 9 7 5

larkcrafts.com

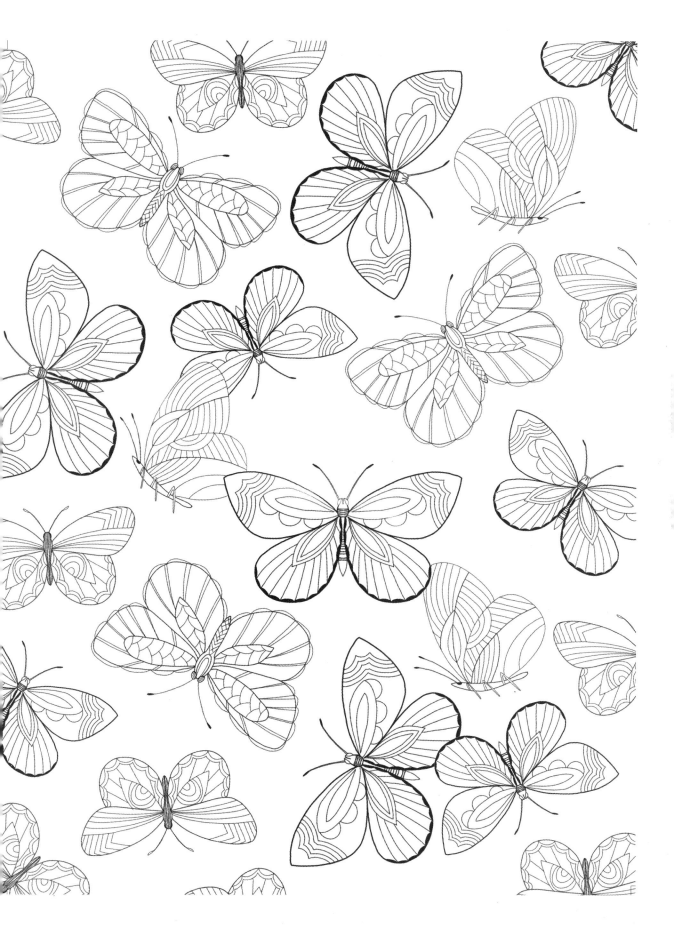

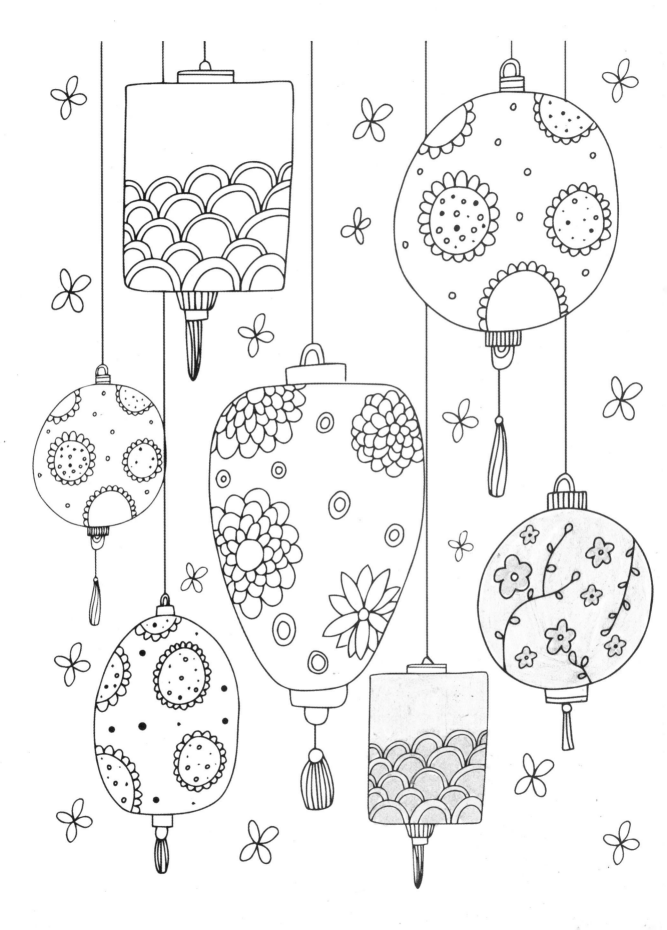

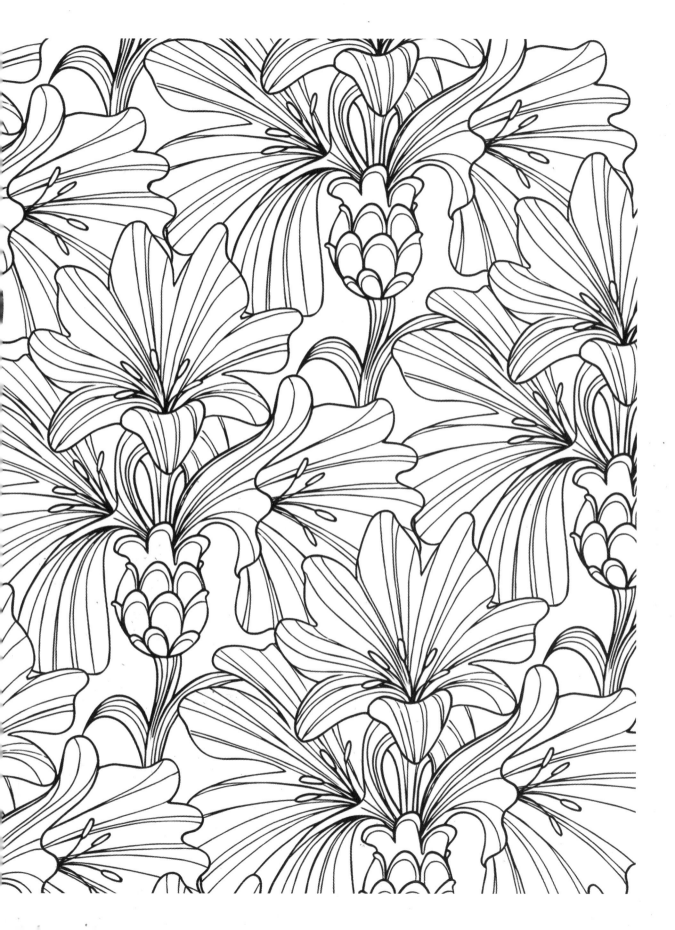

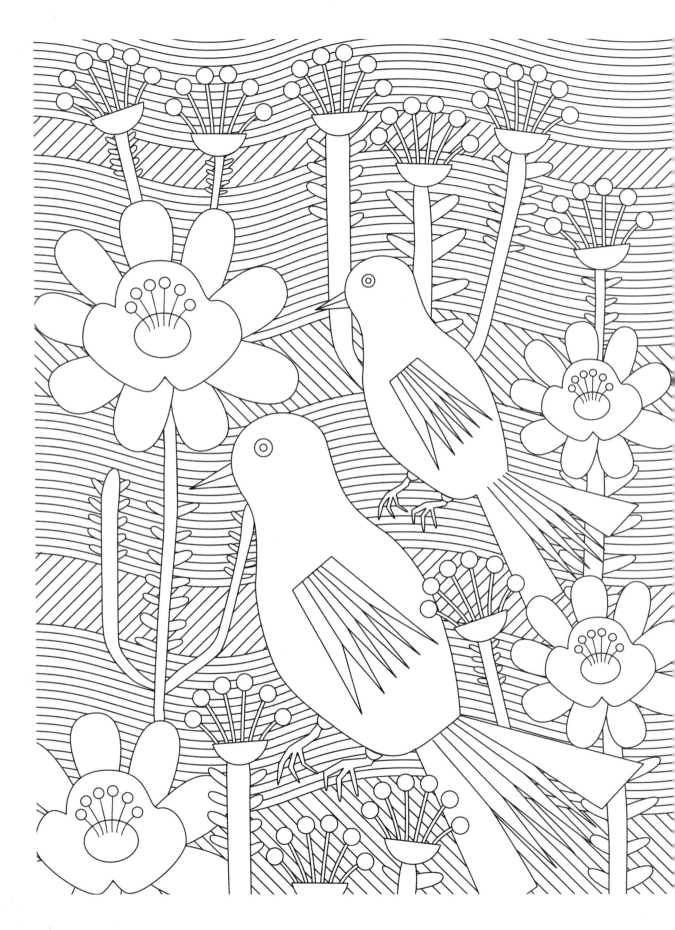

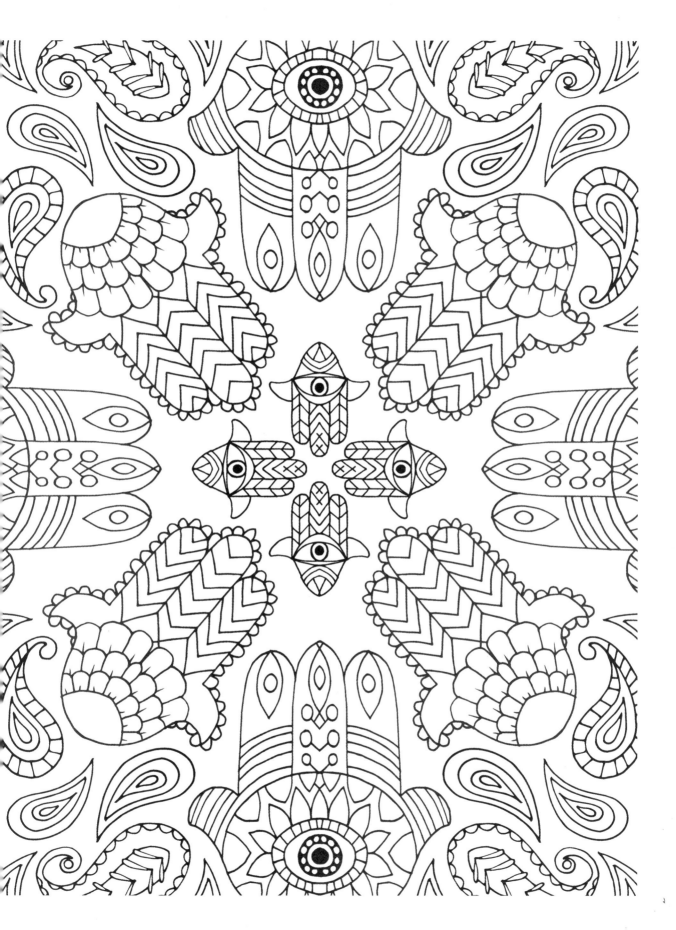

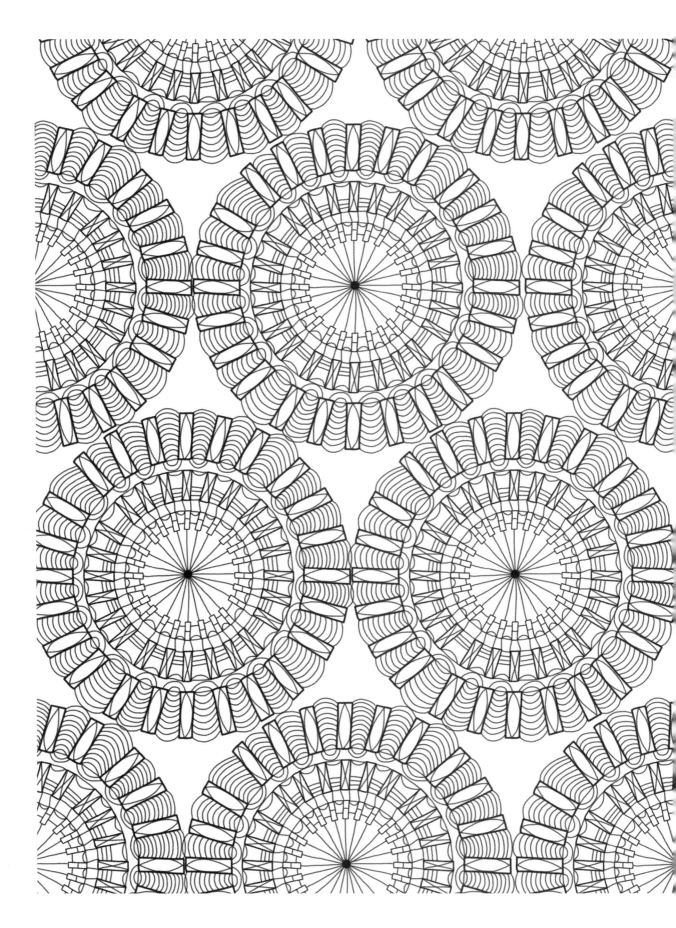

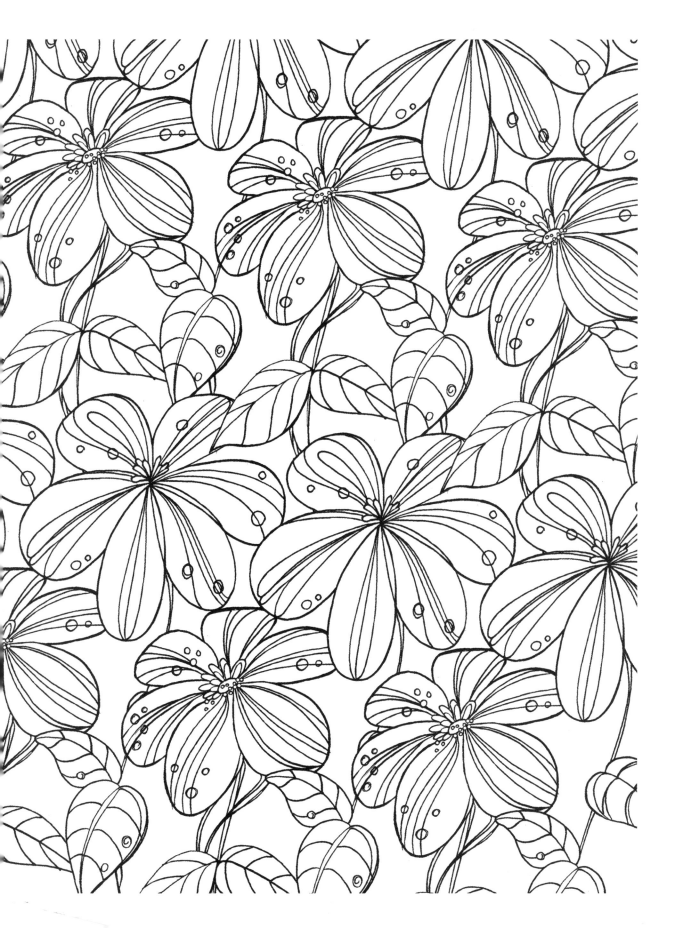

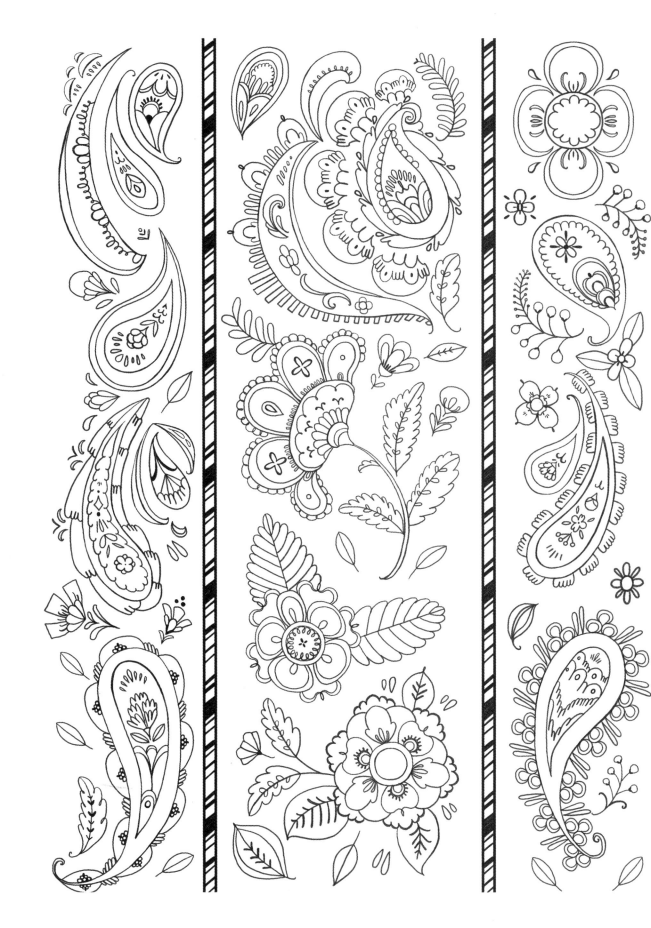

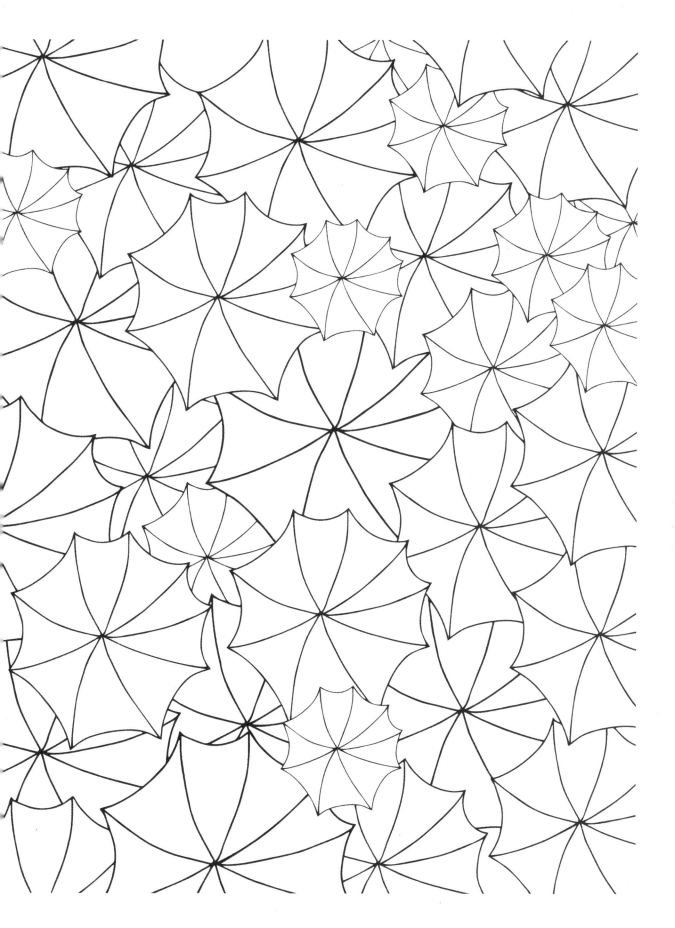

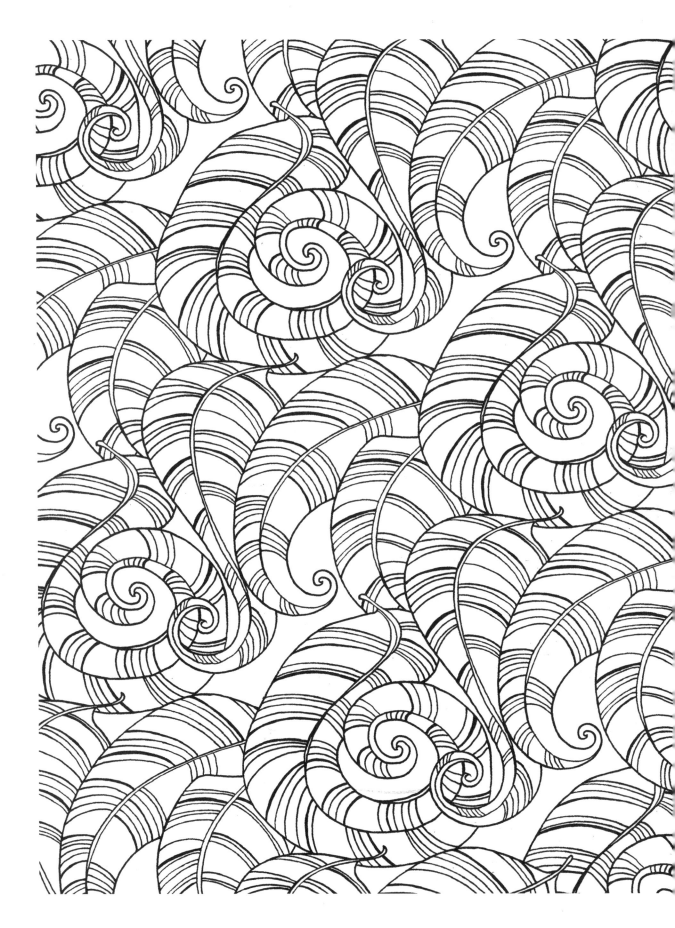

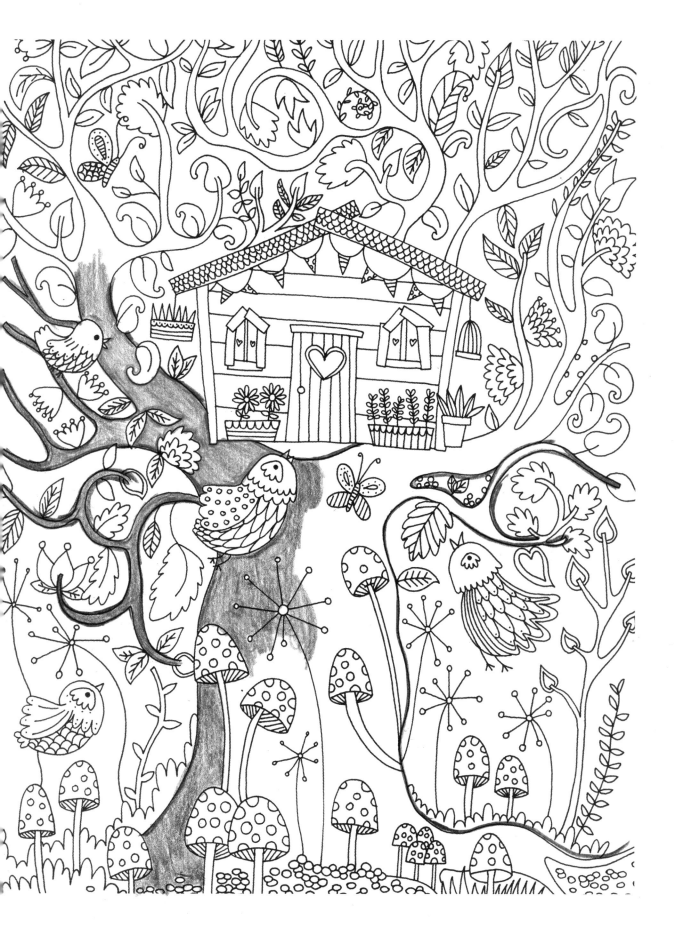

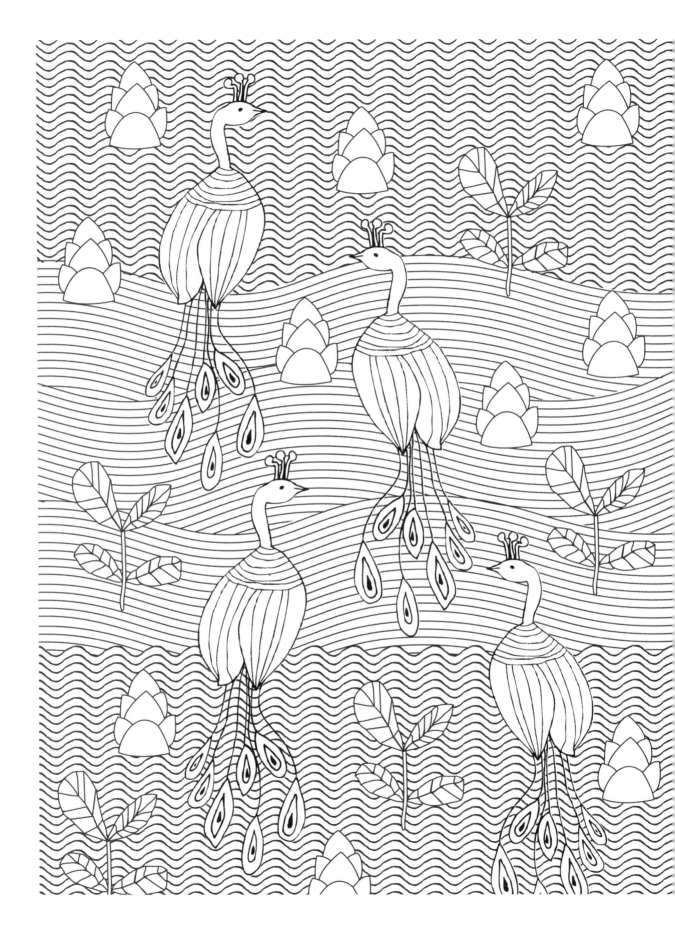

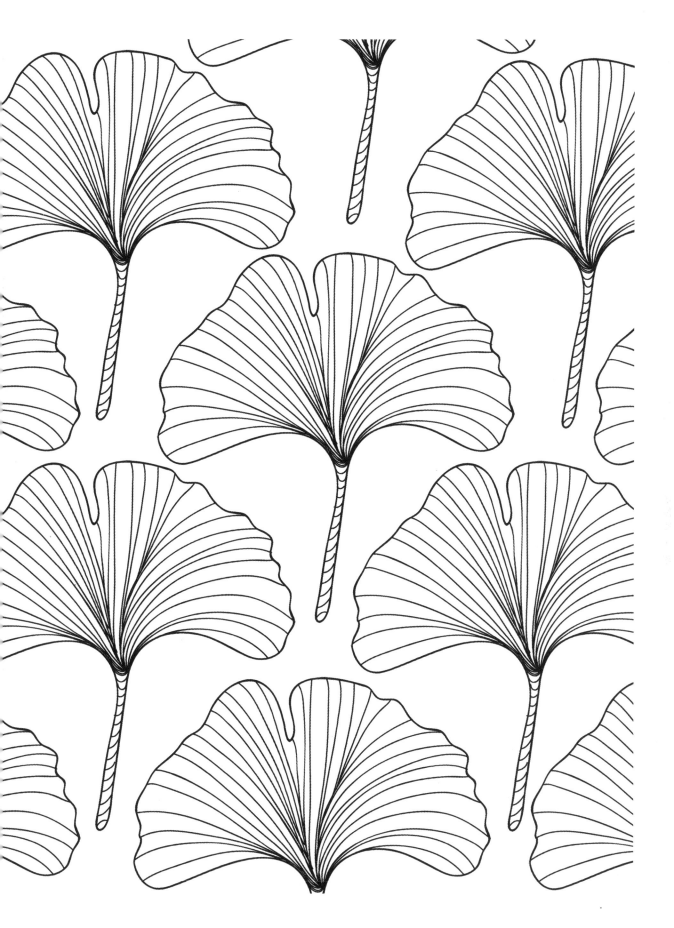

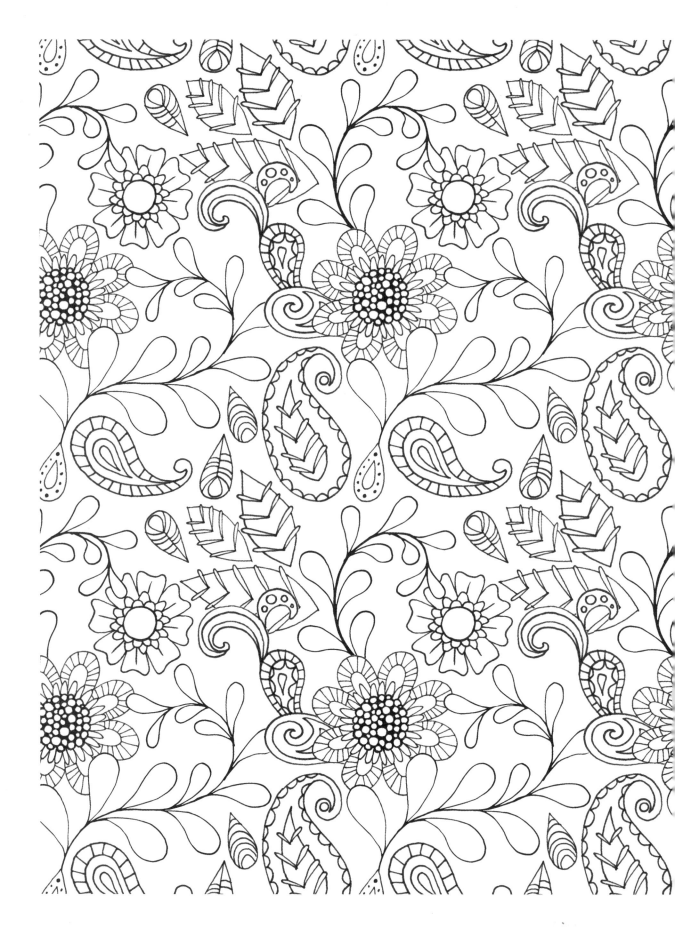

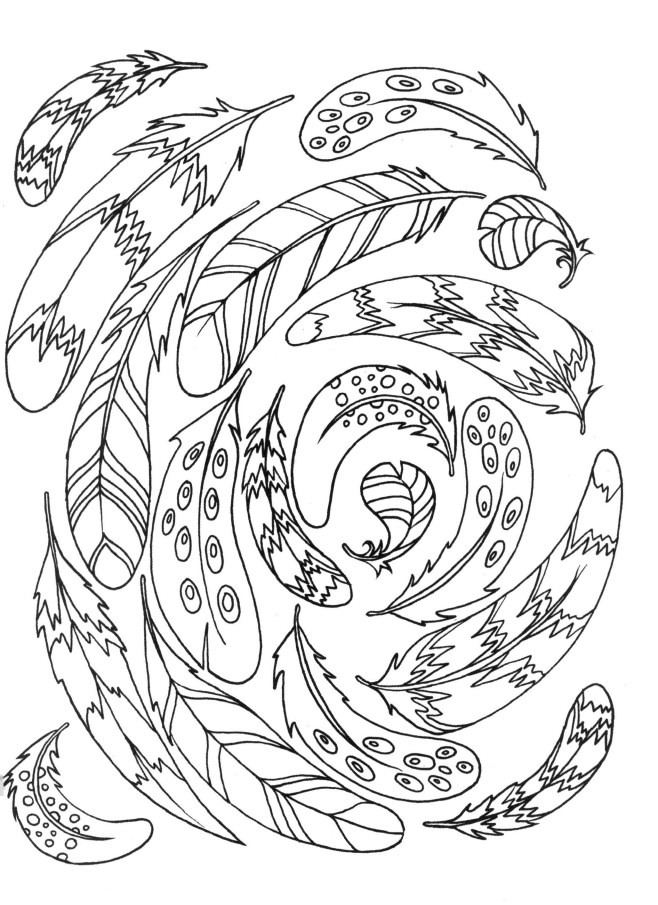

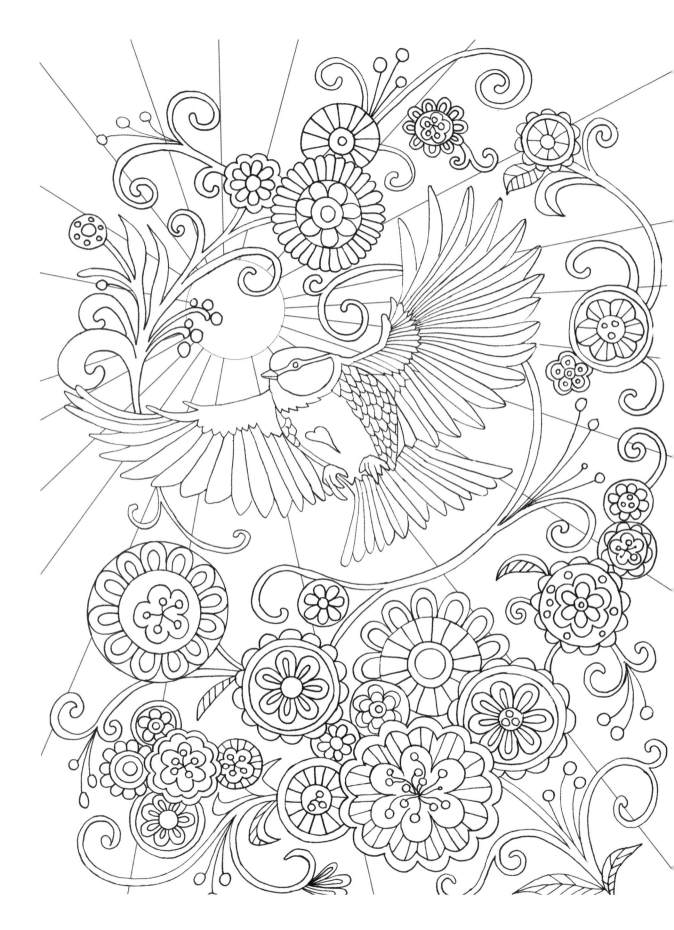

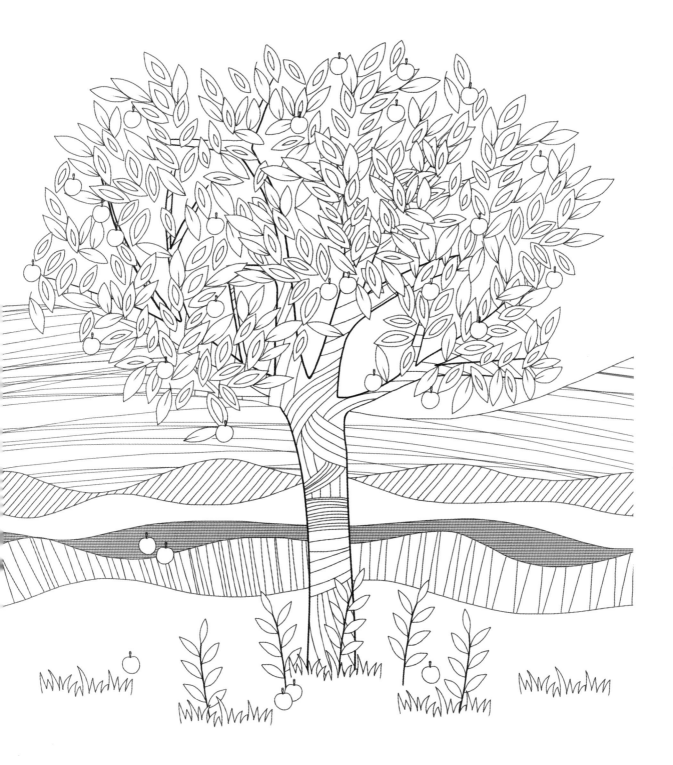

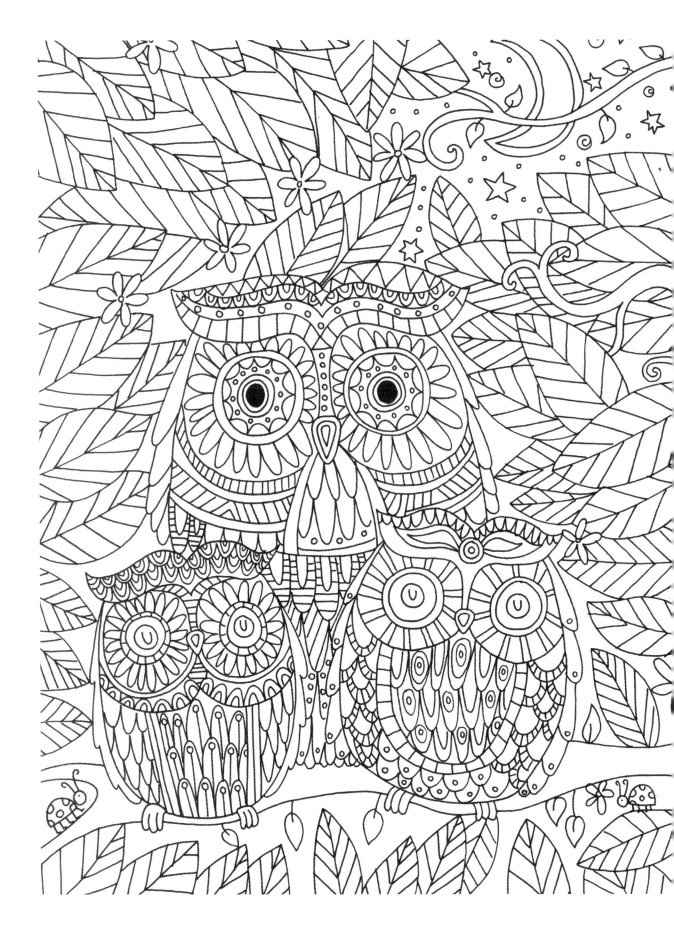

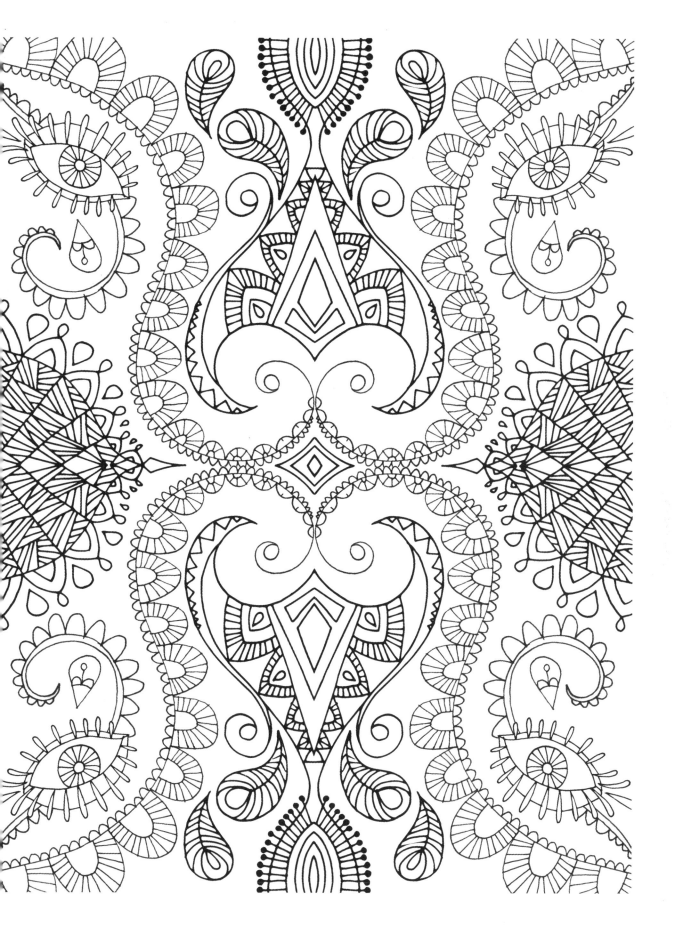

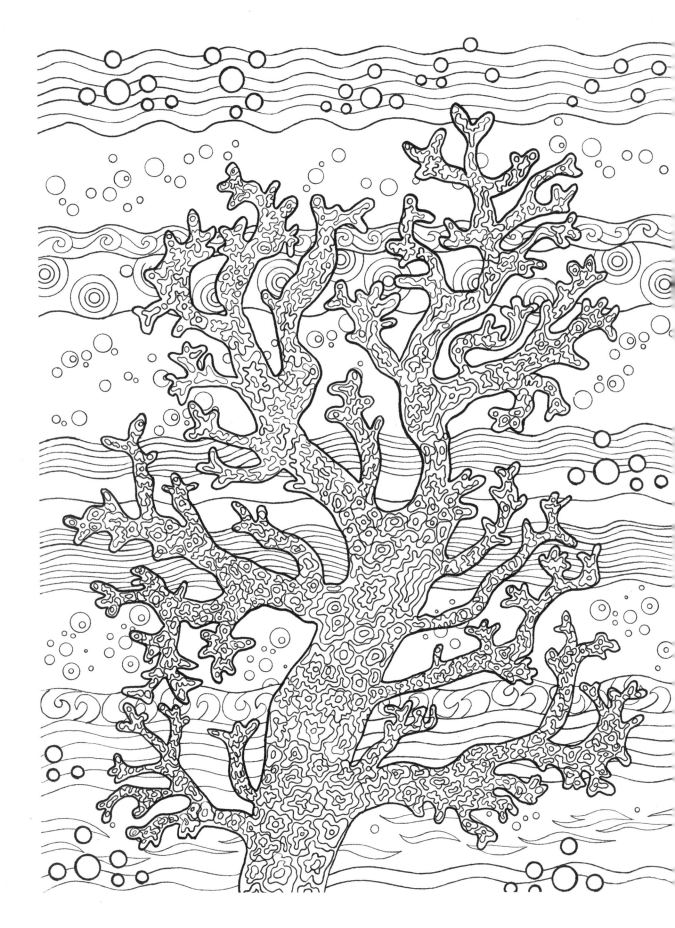

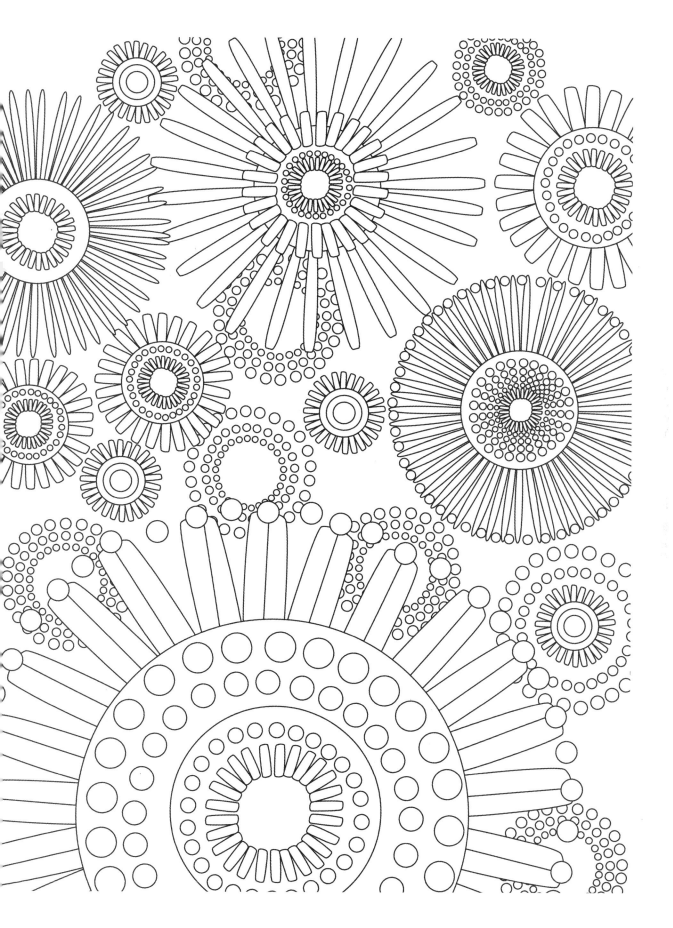

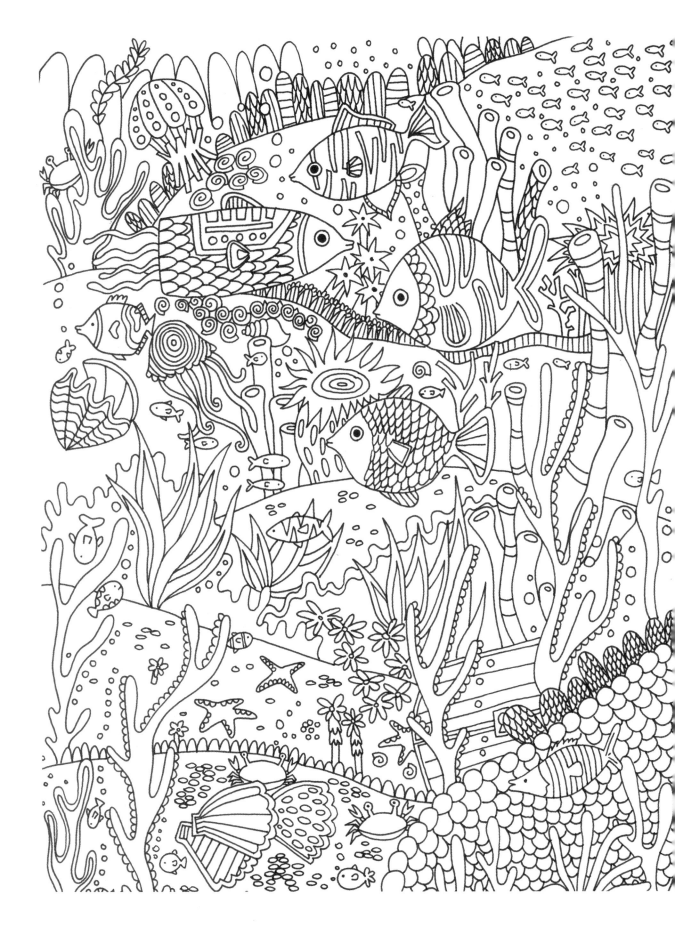

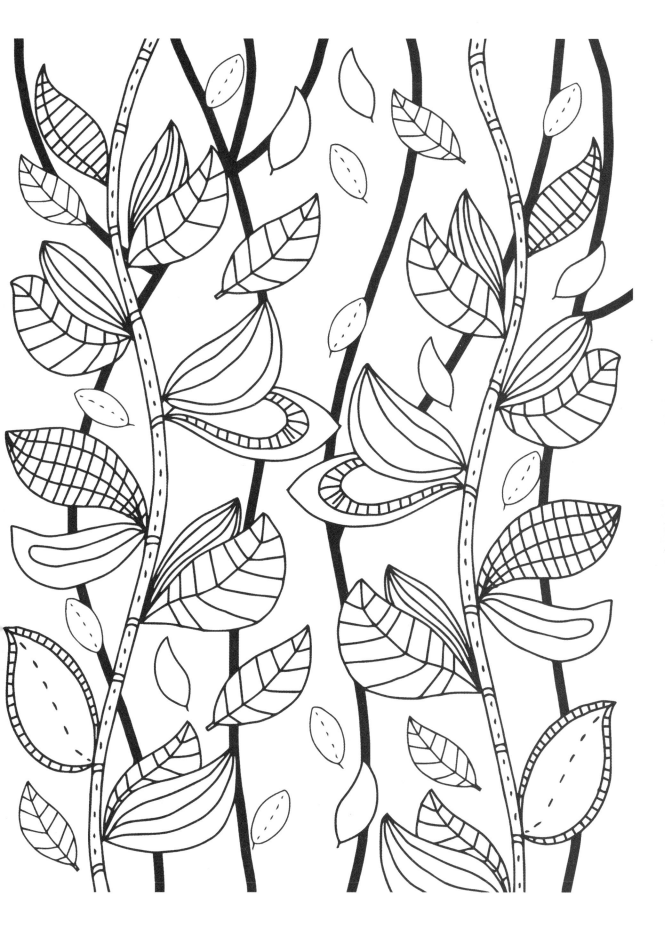

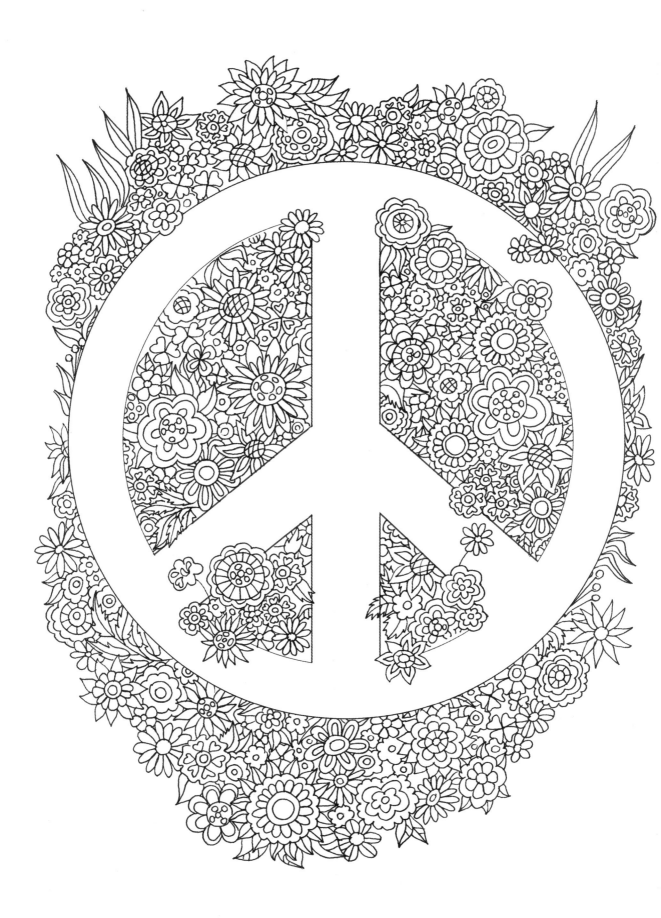

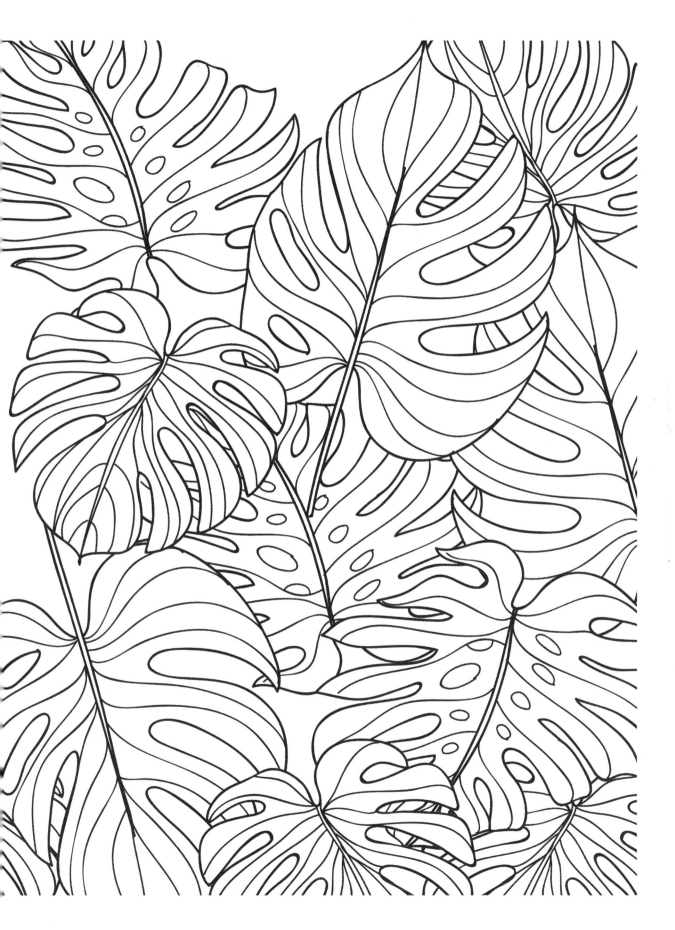

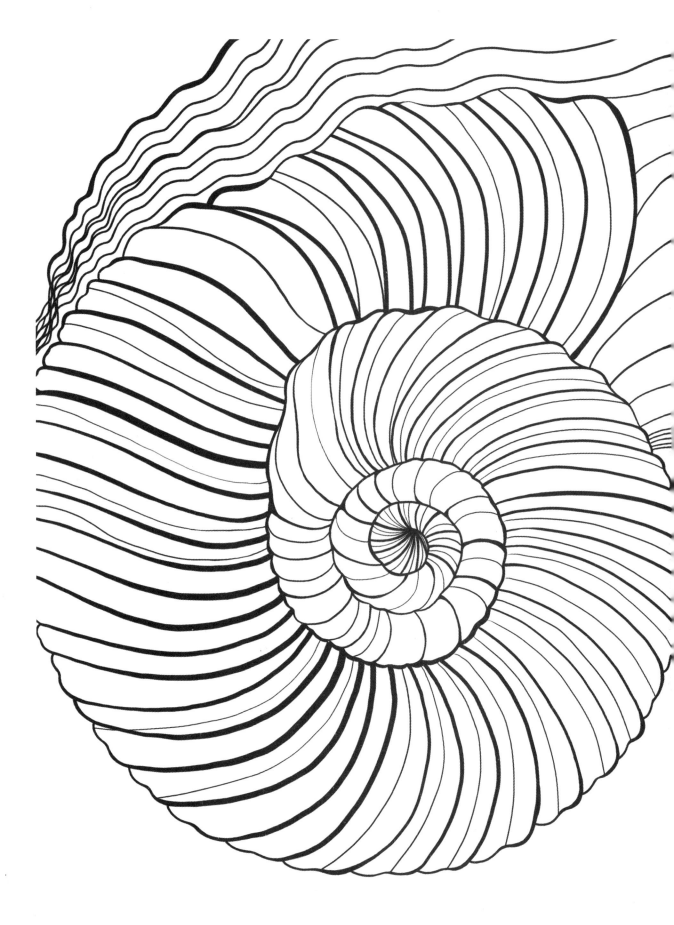

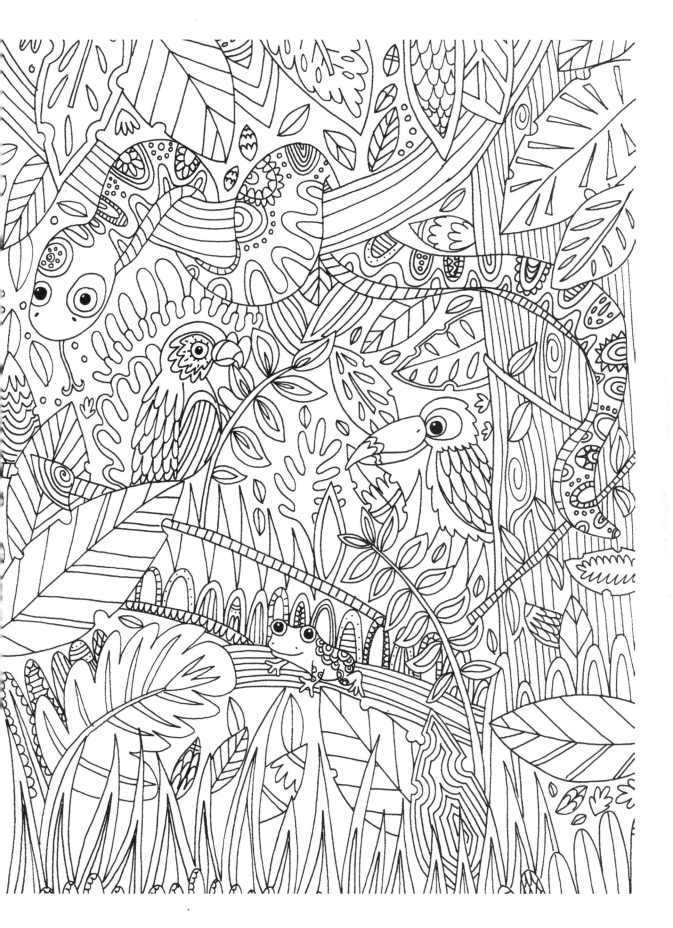

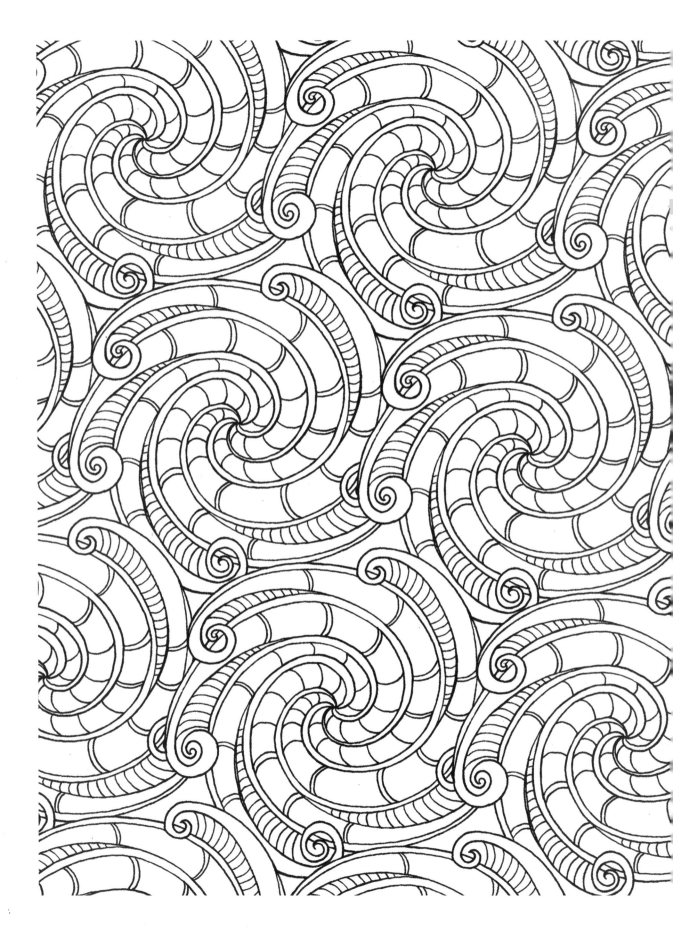

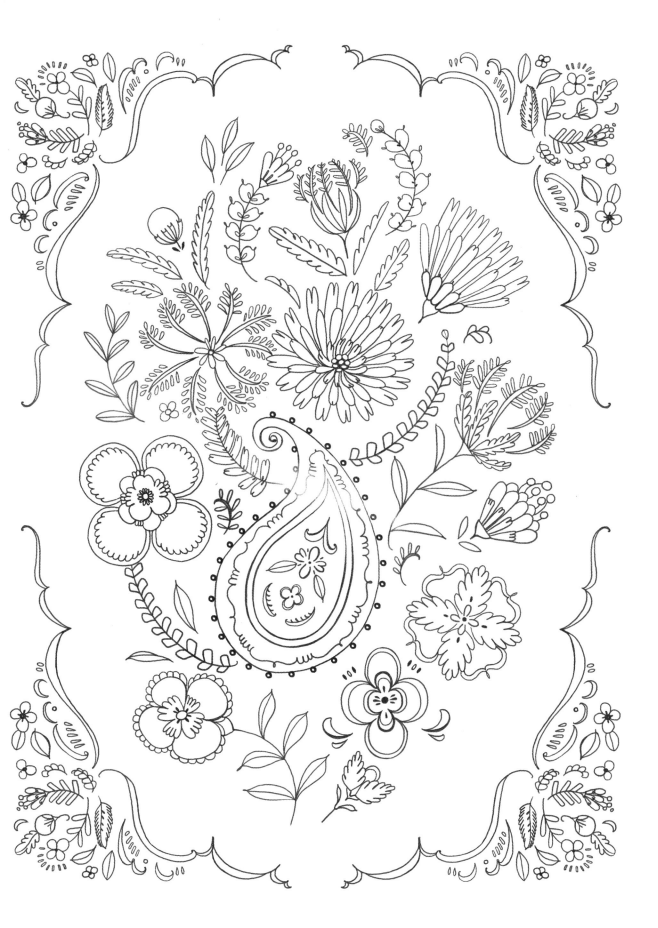

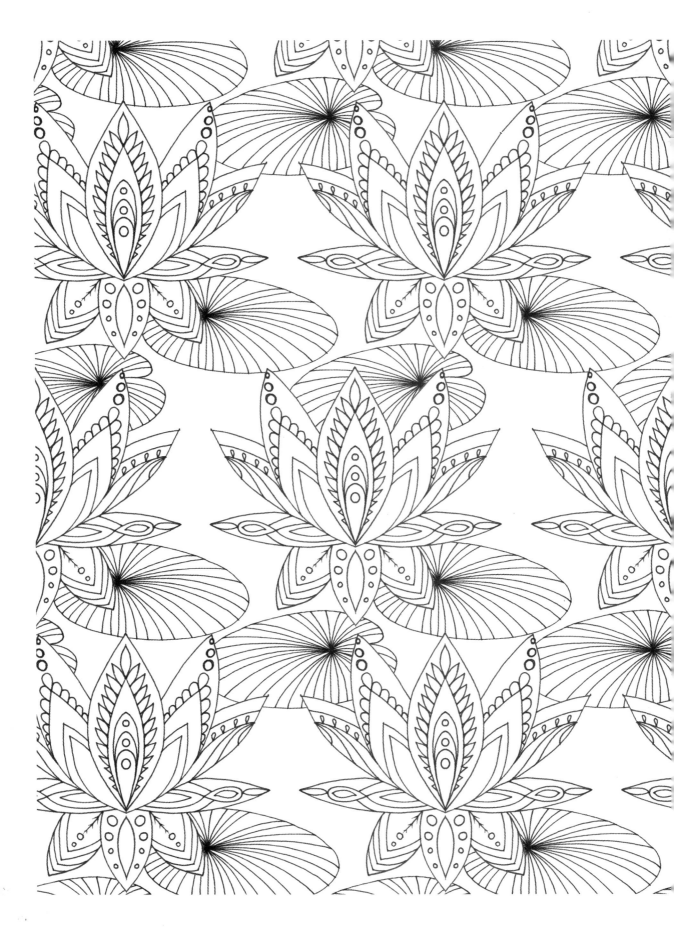

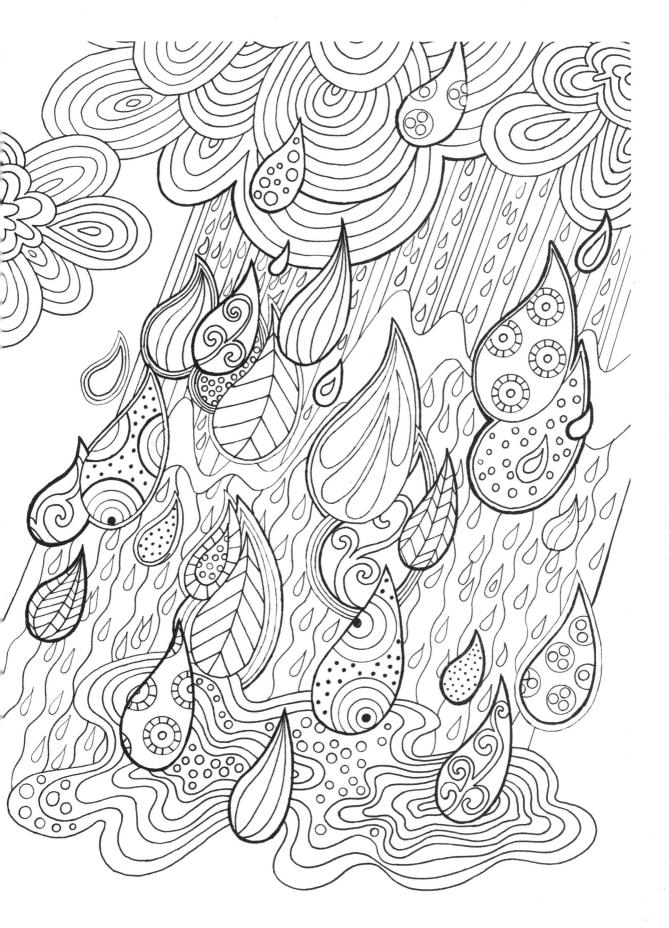

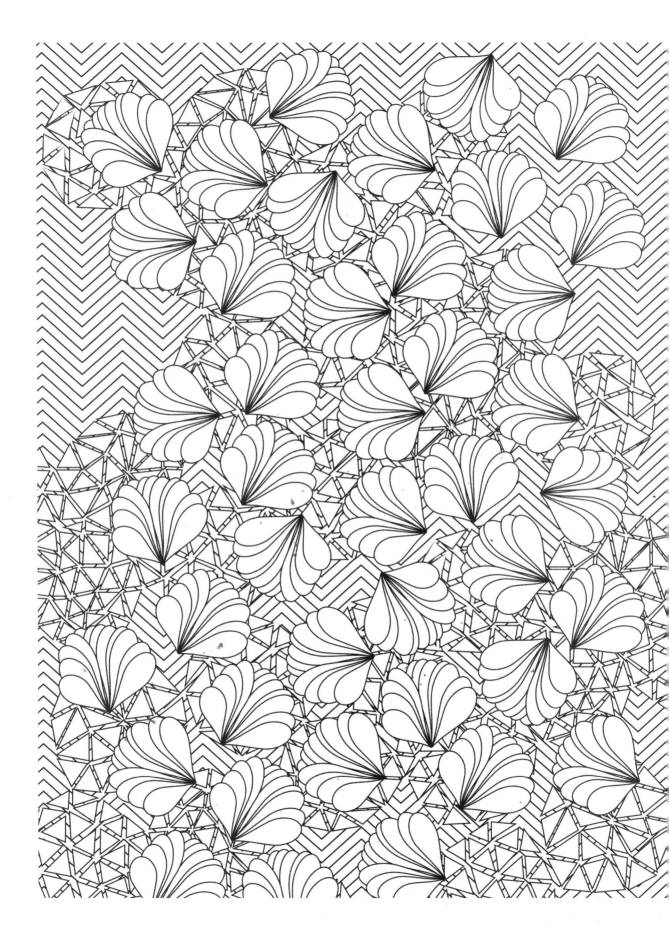

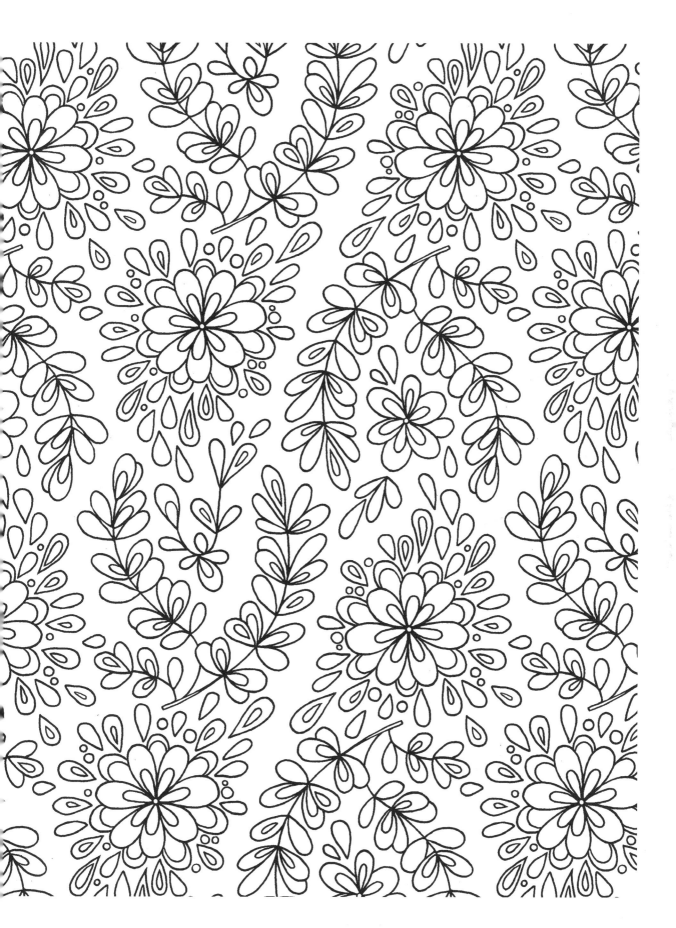

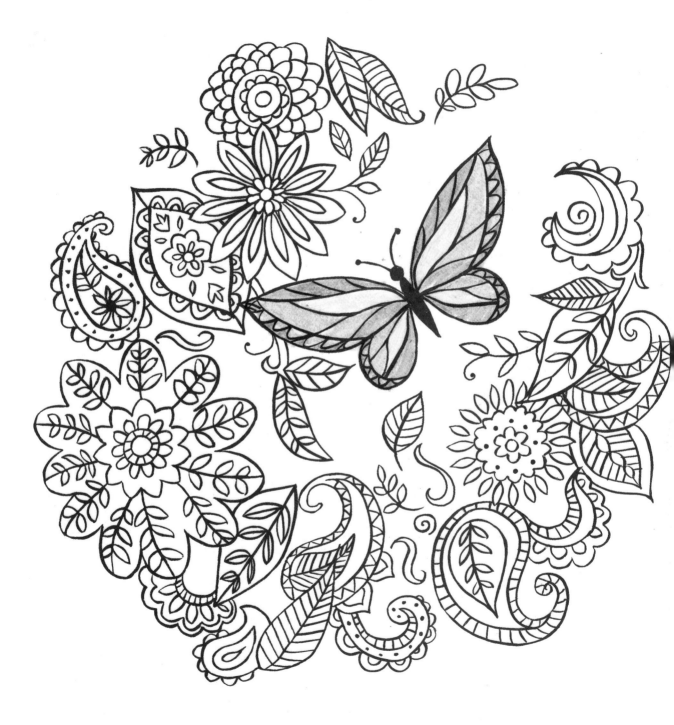

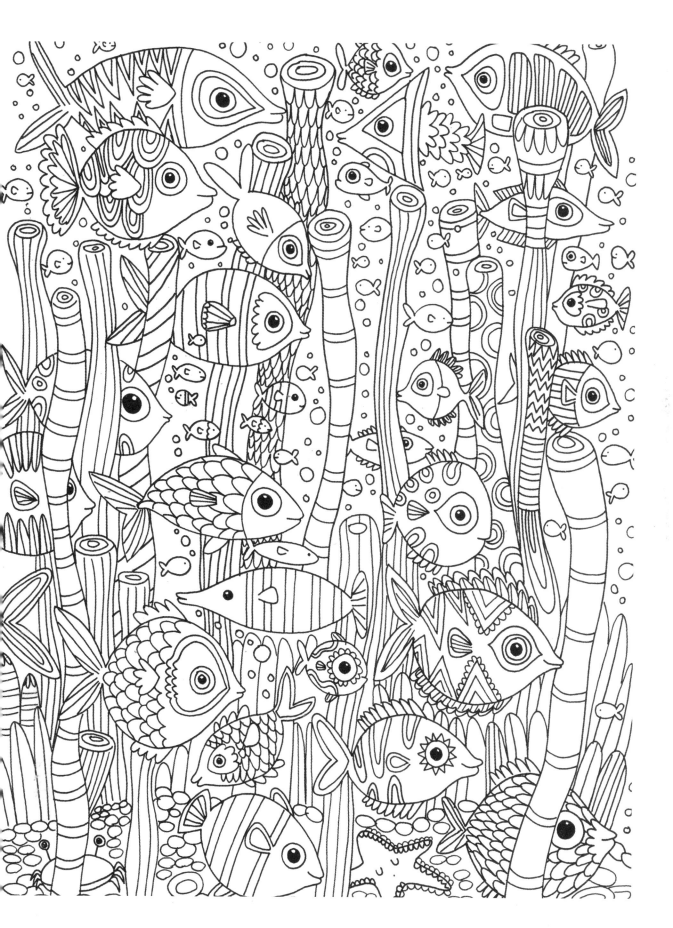

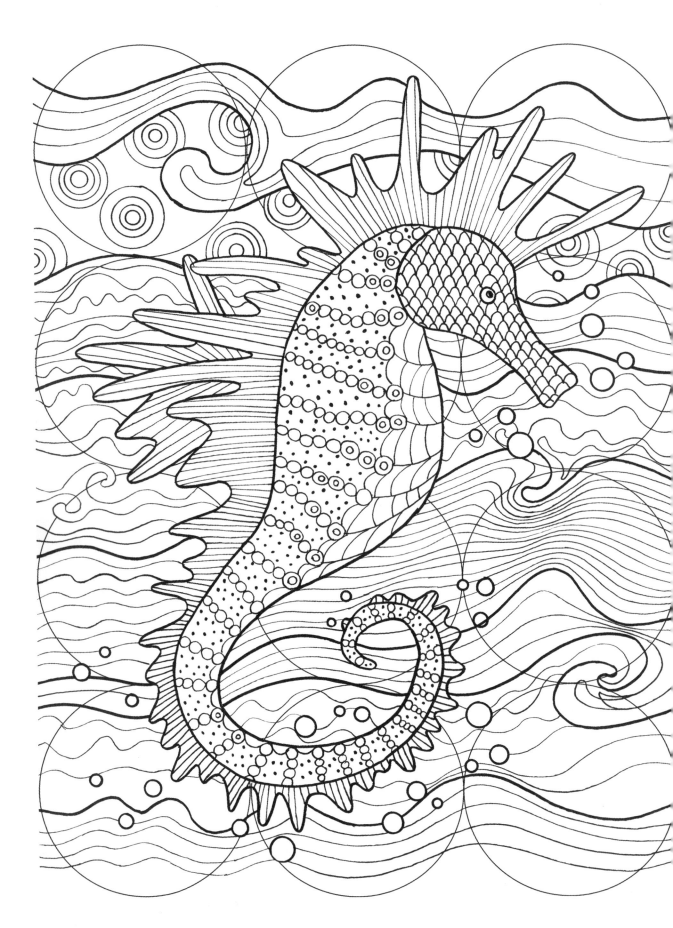

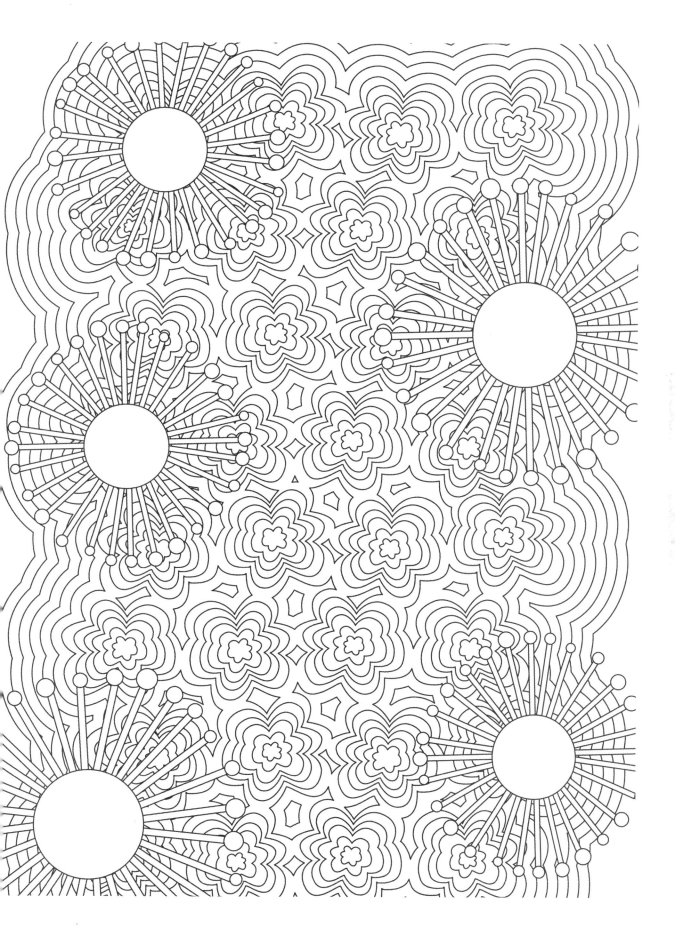

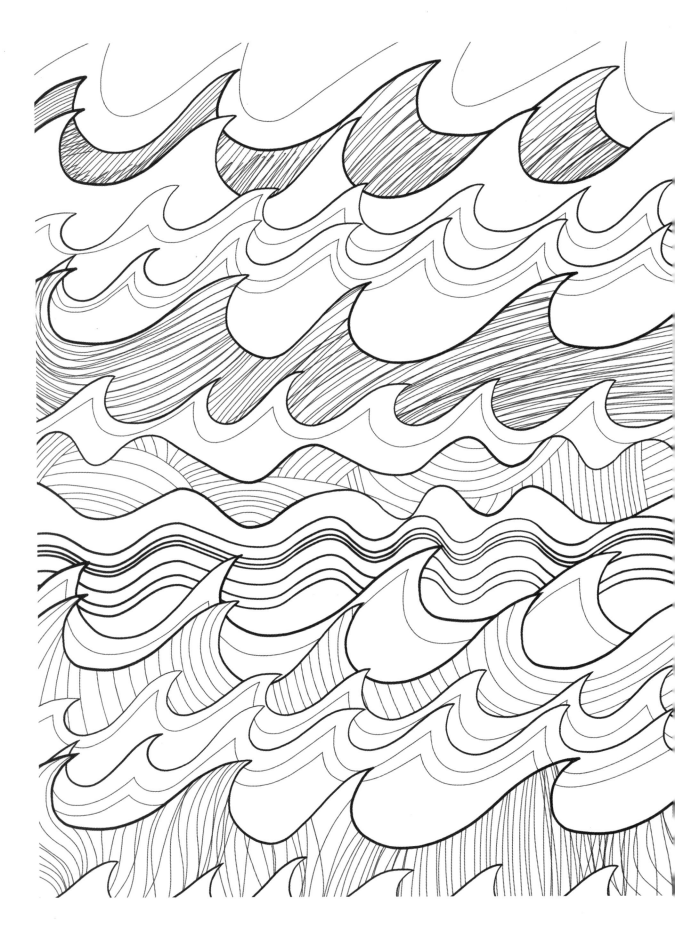

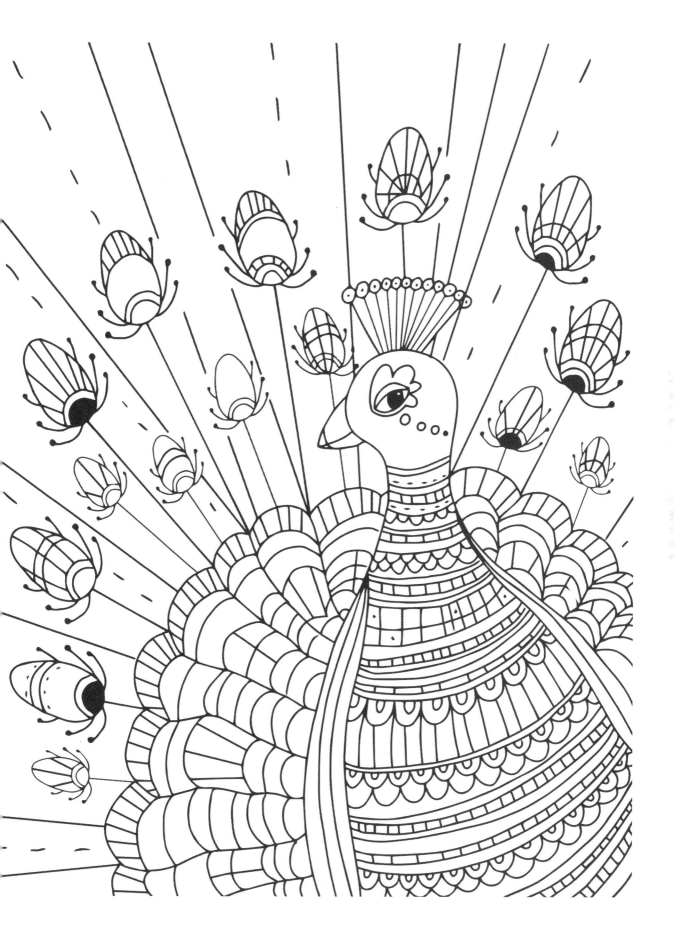

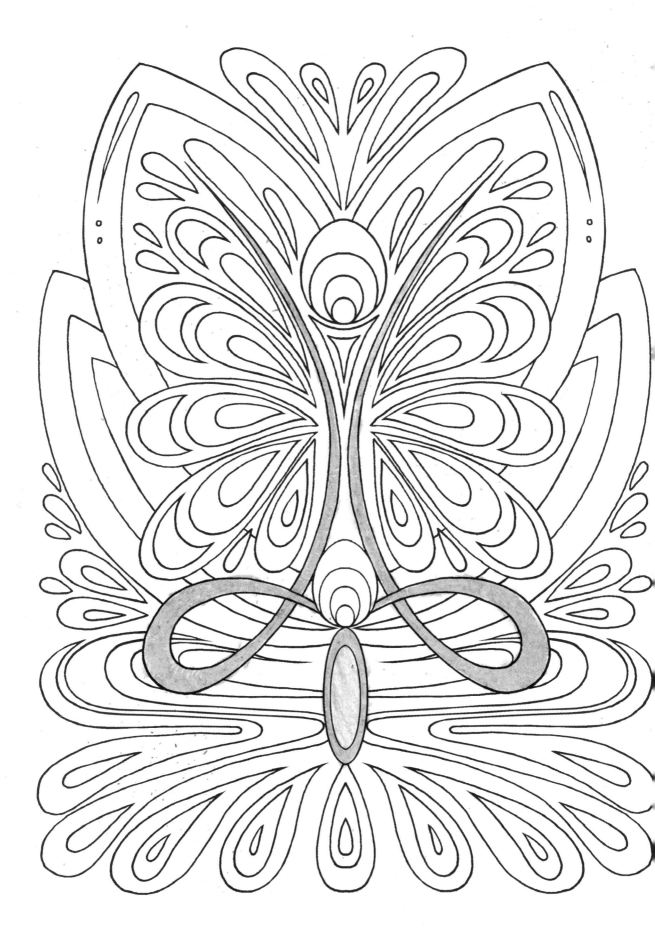

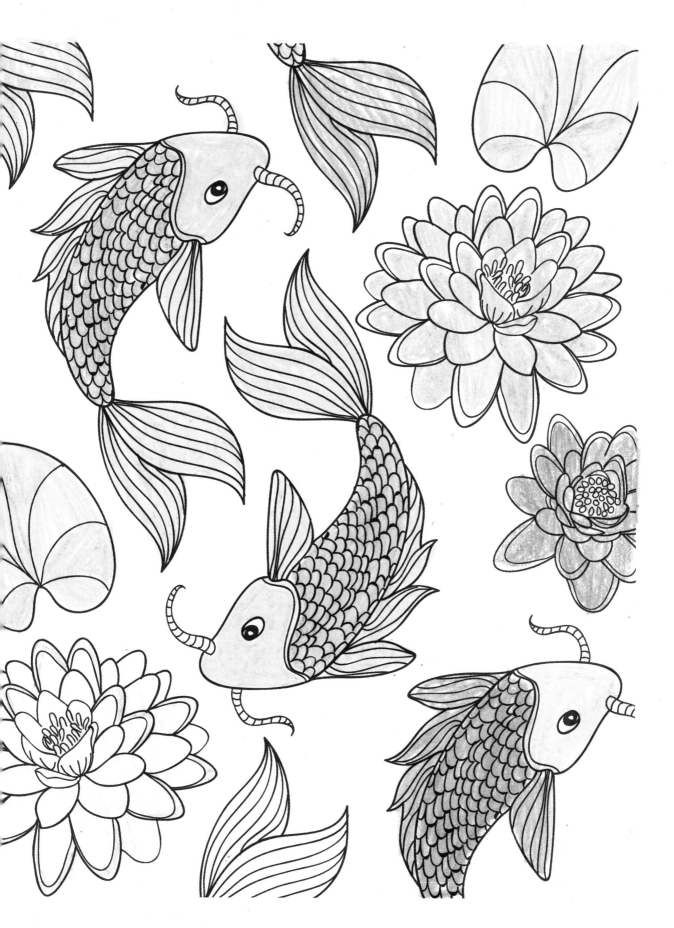

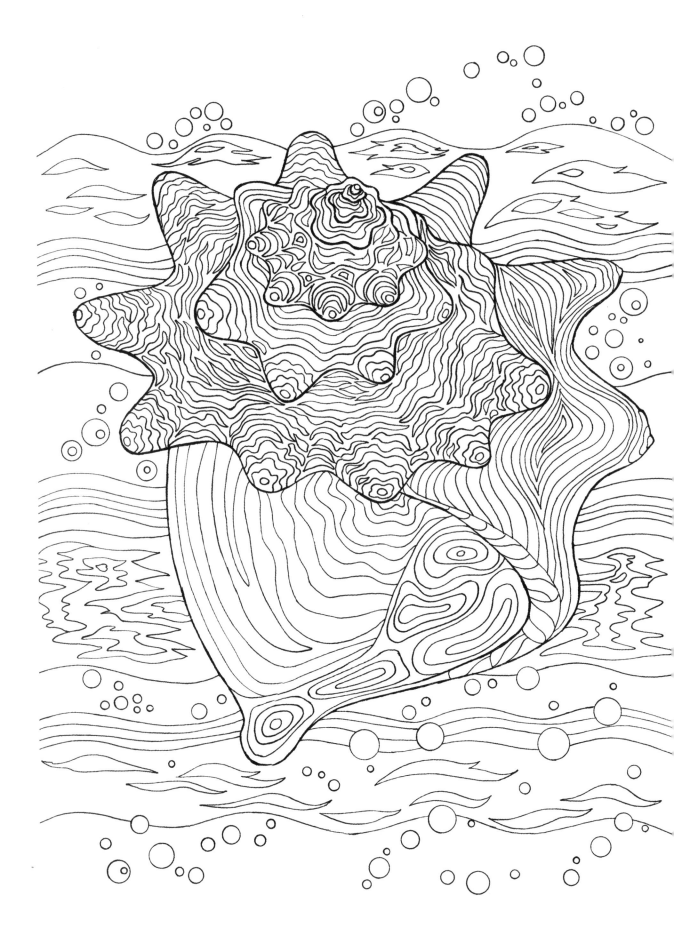

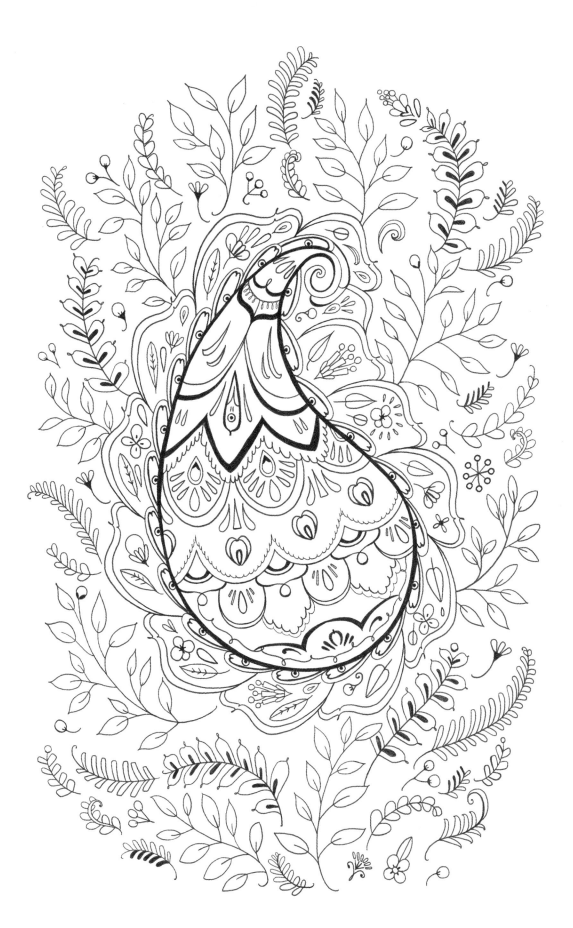

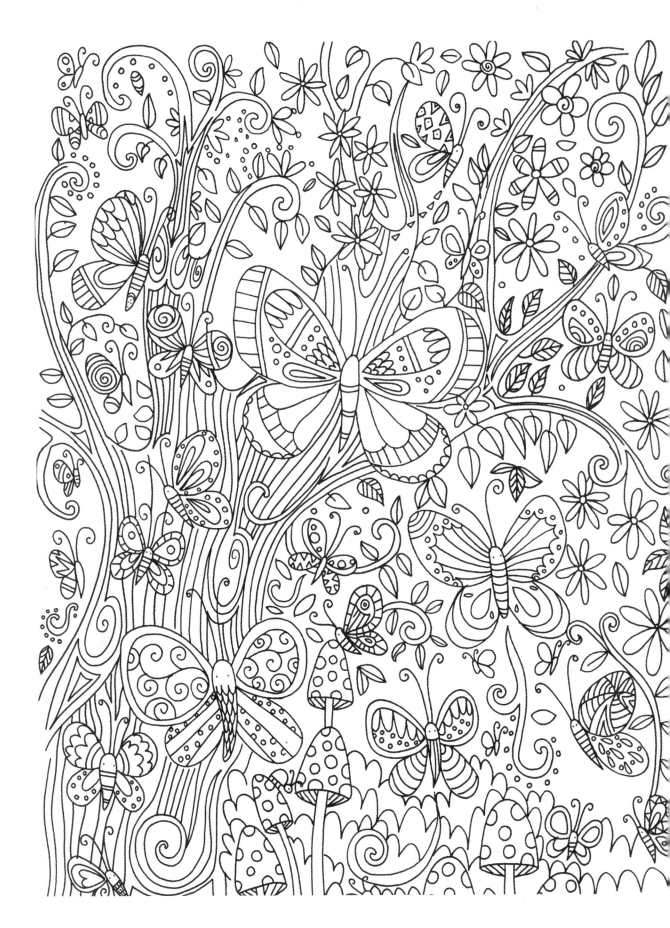

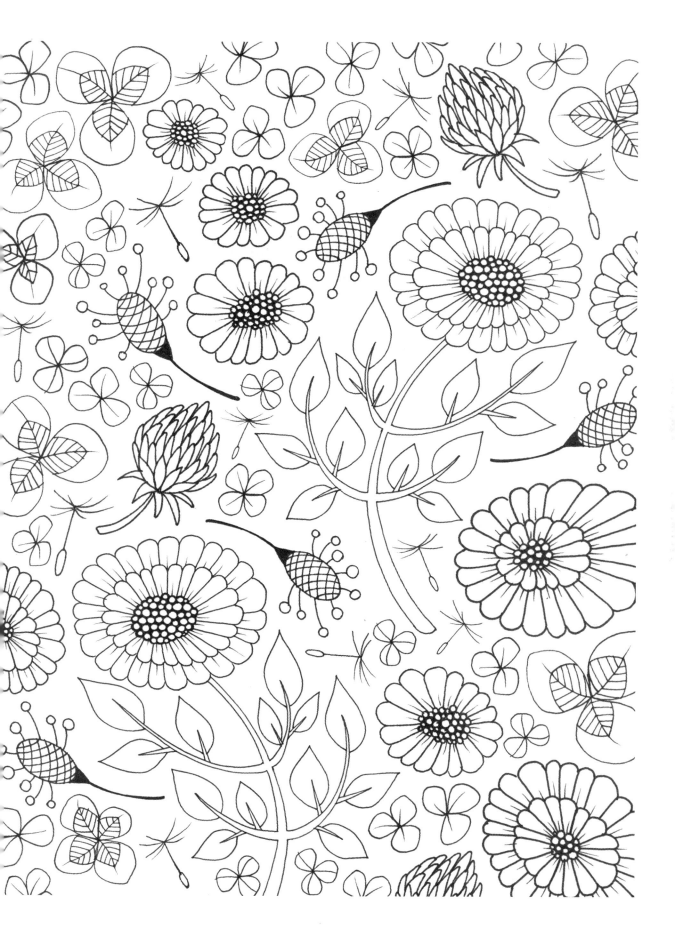

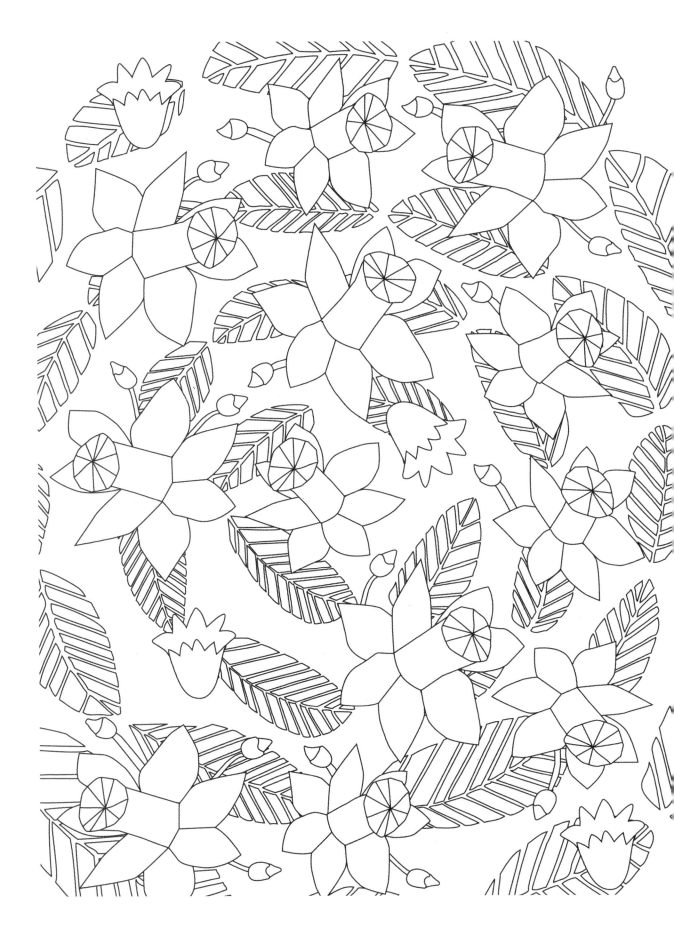

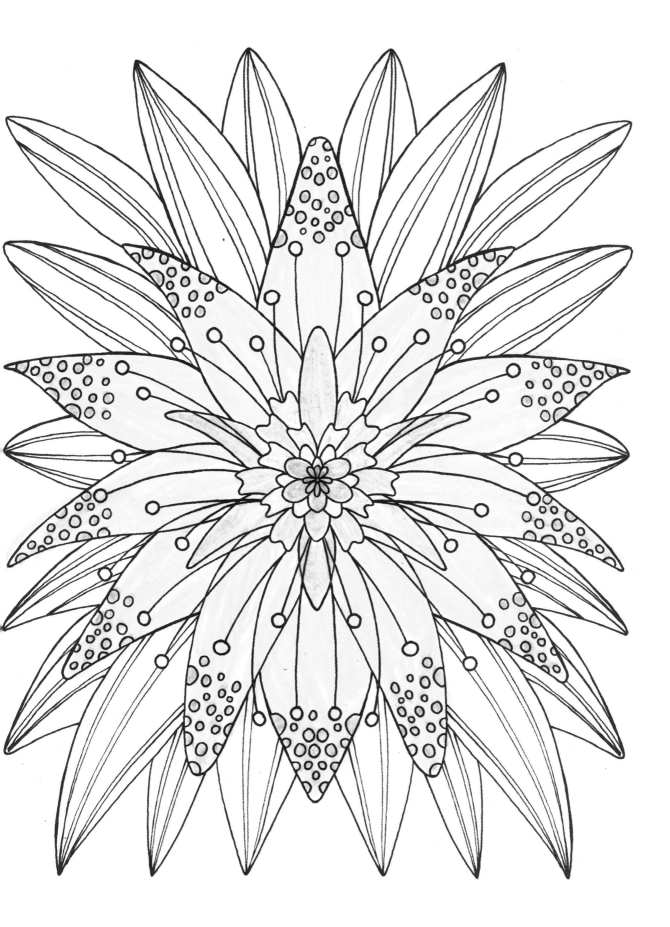

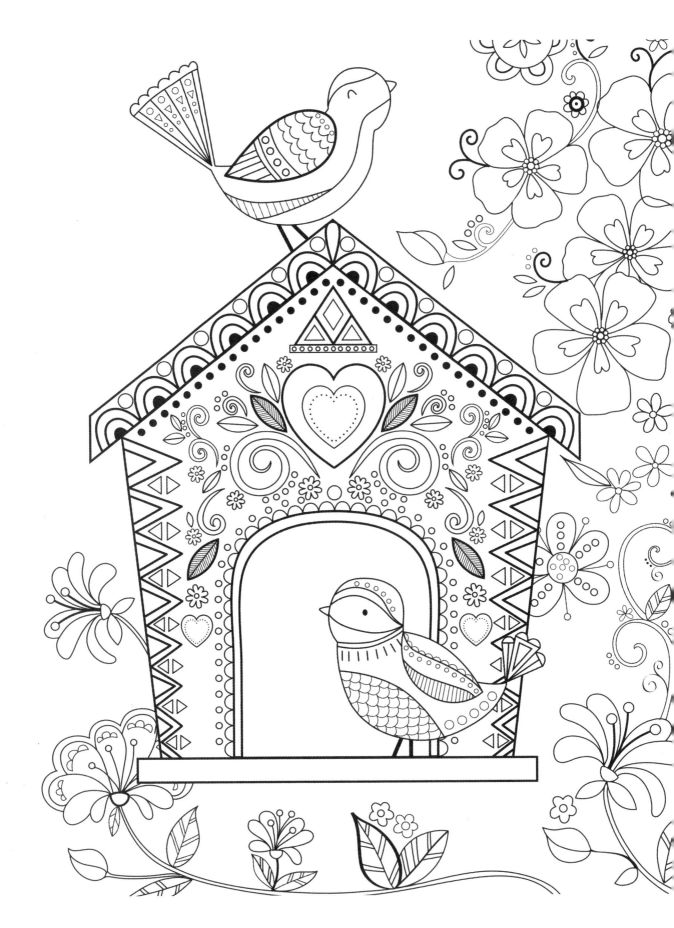

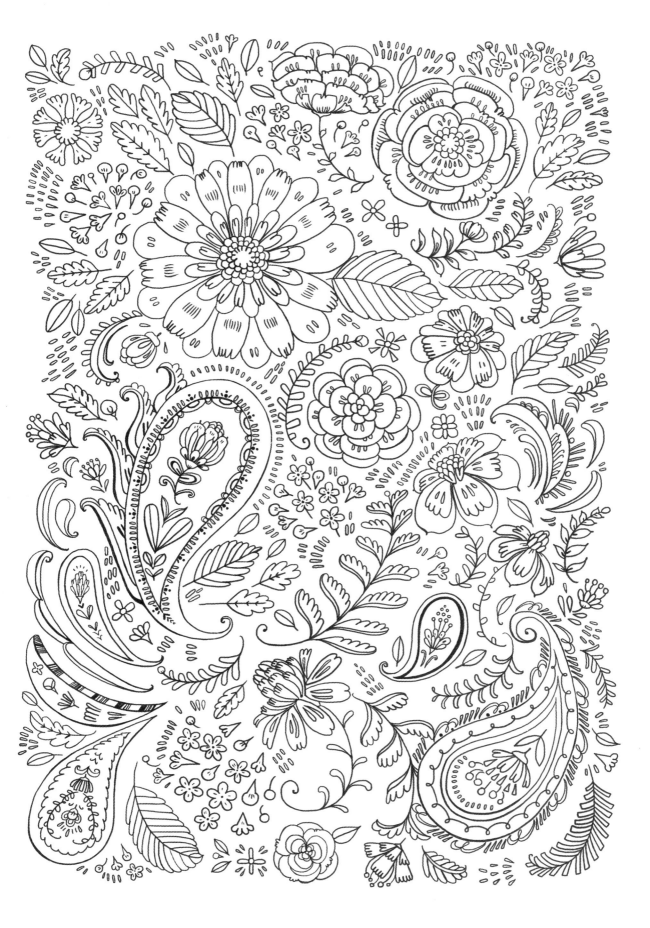

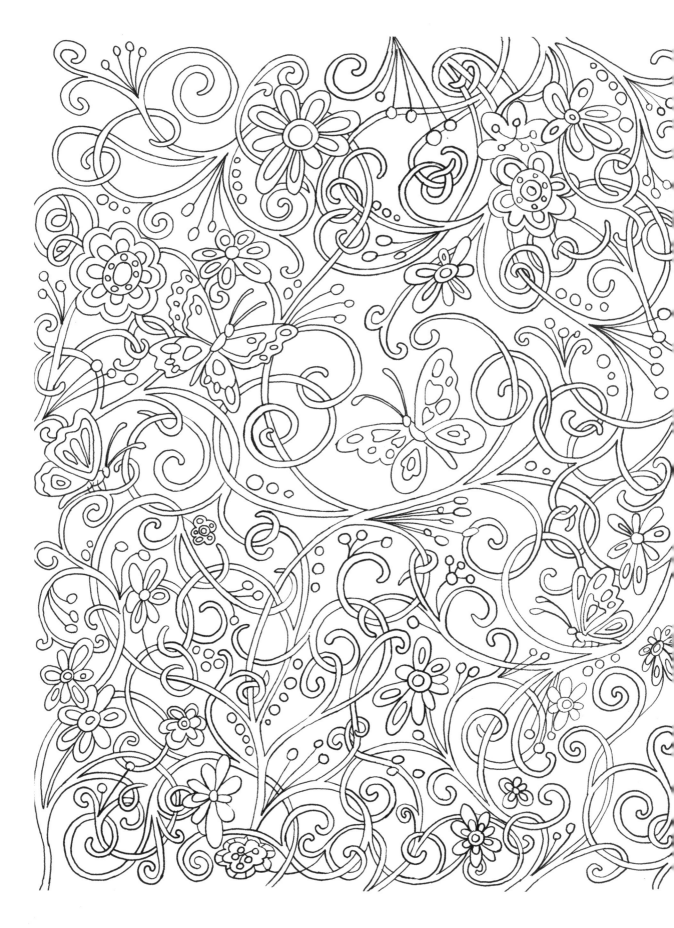

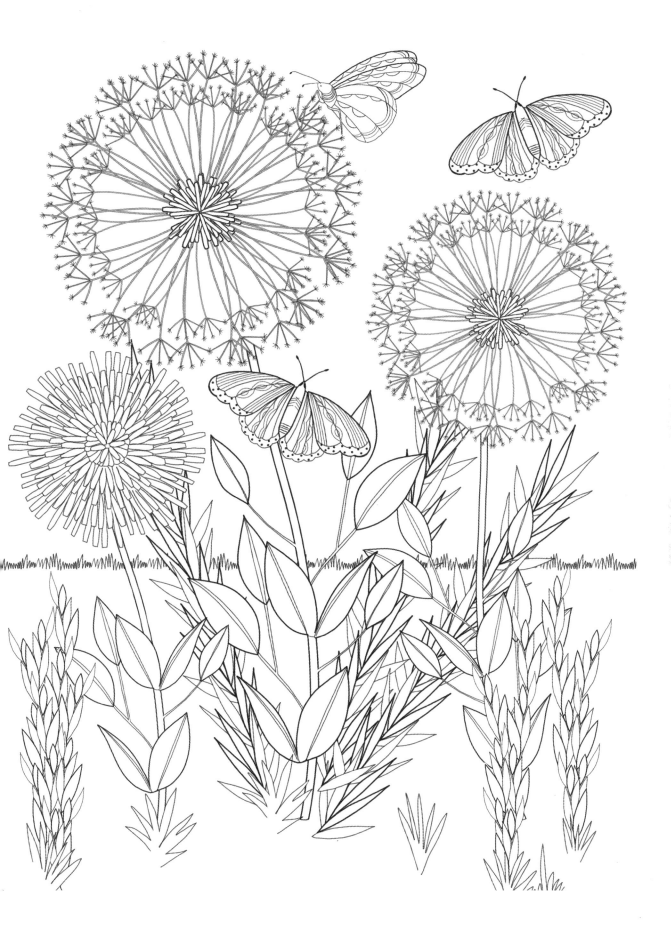

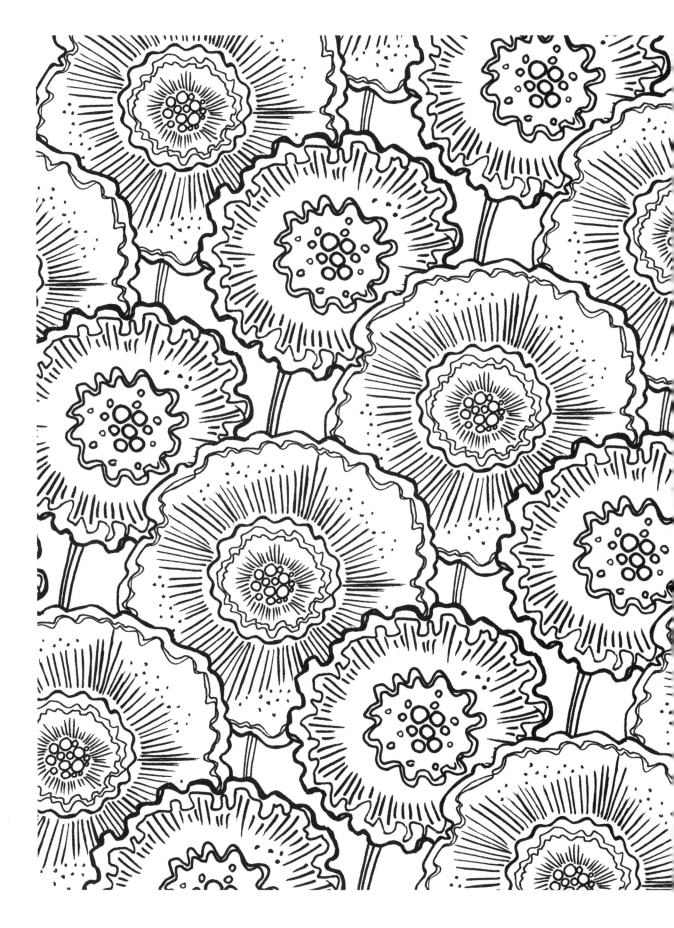

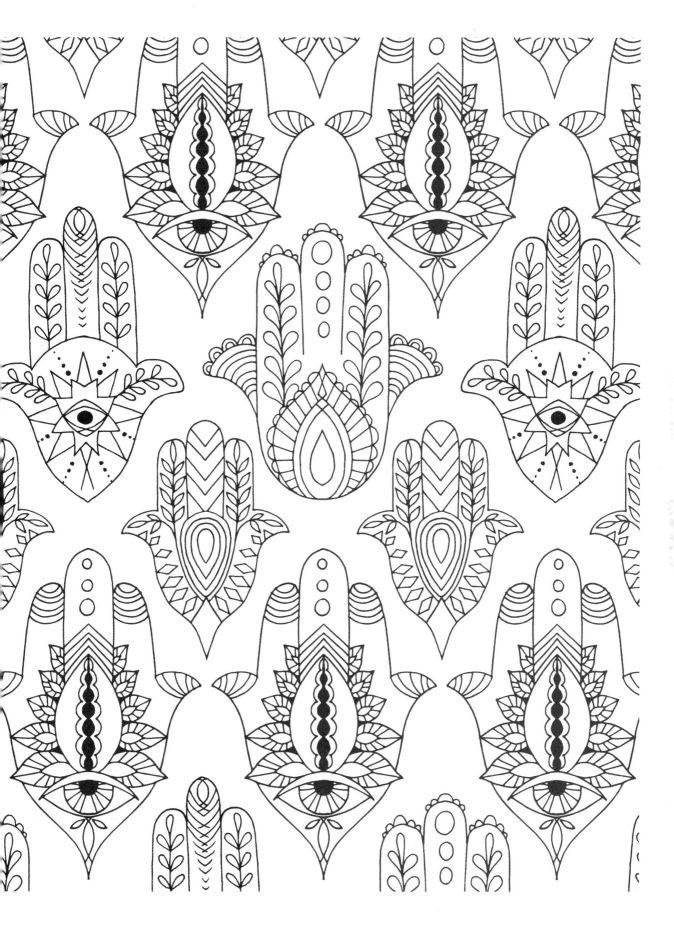

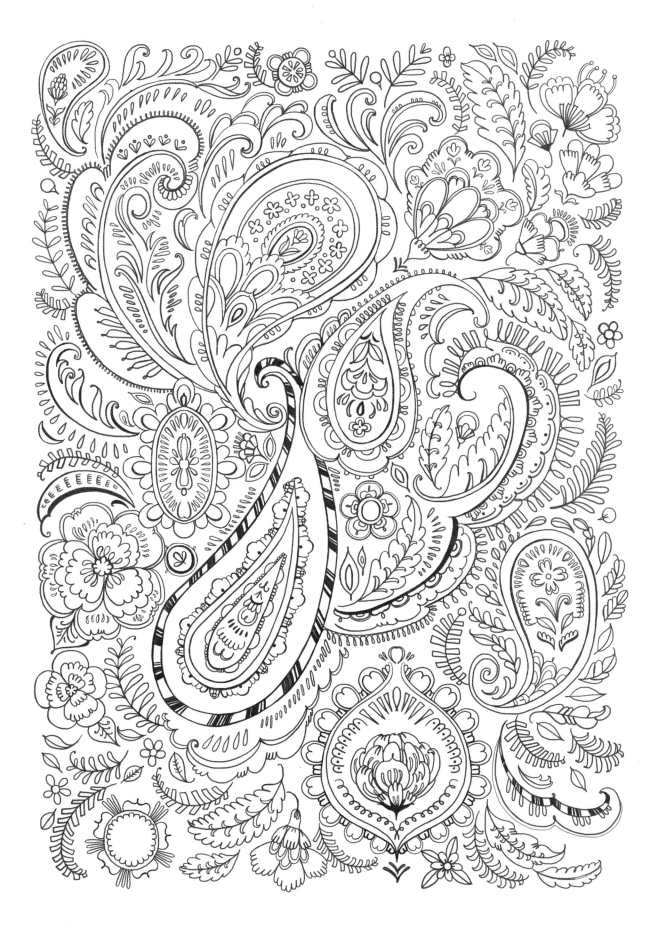

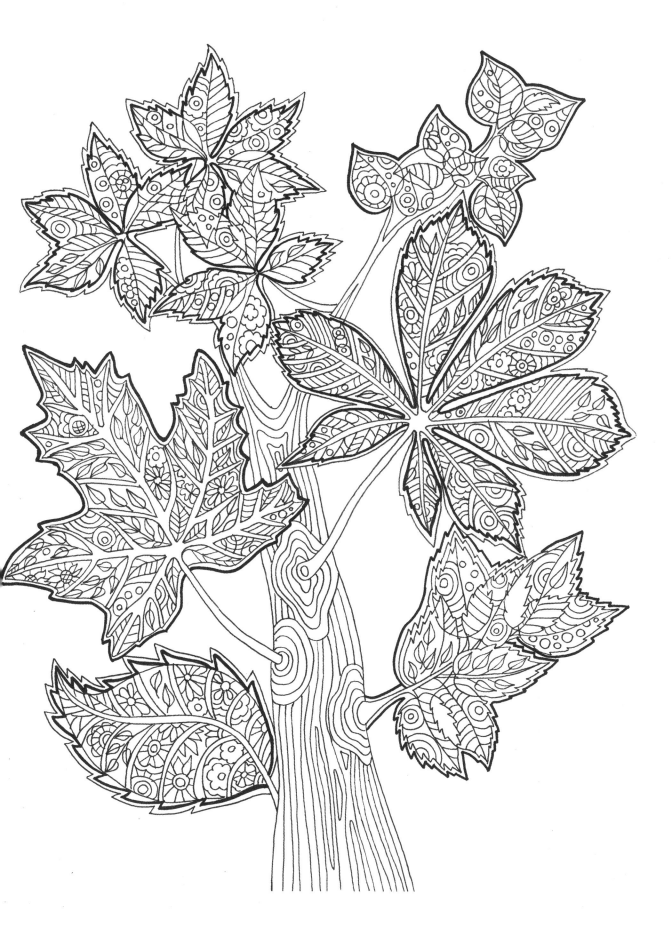

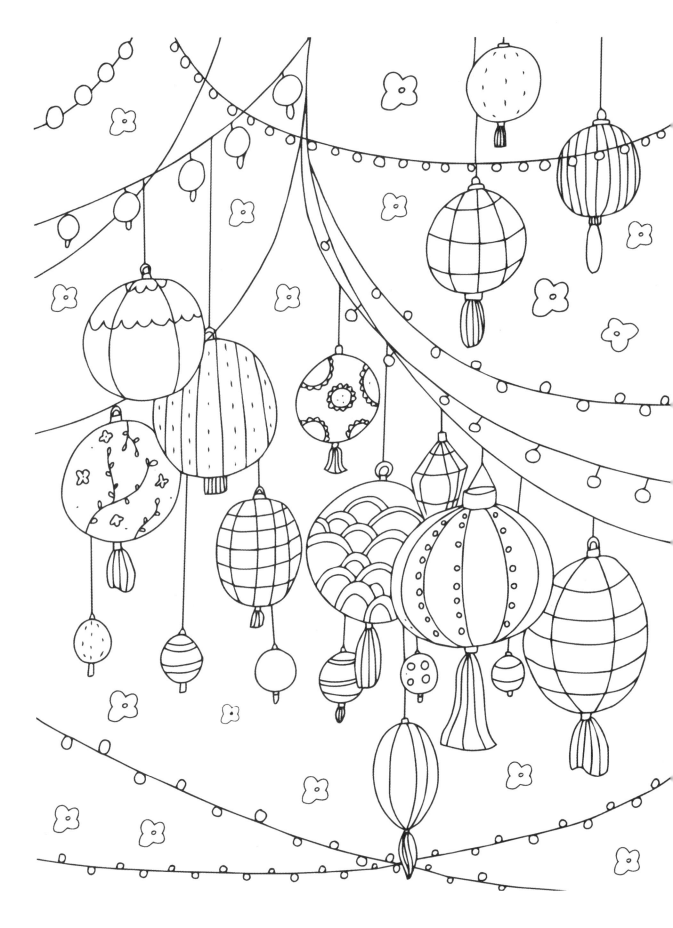

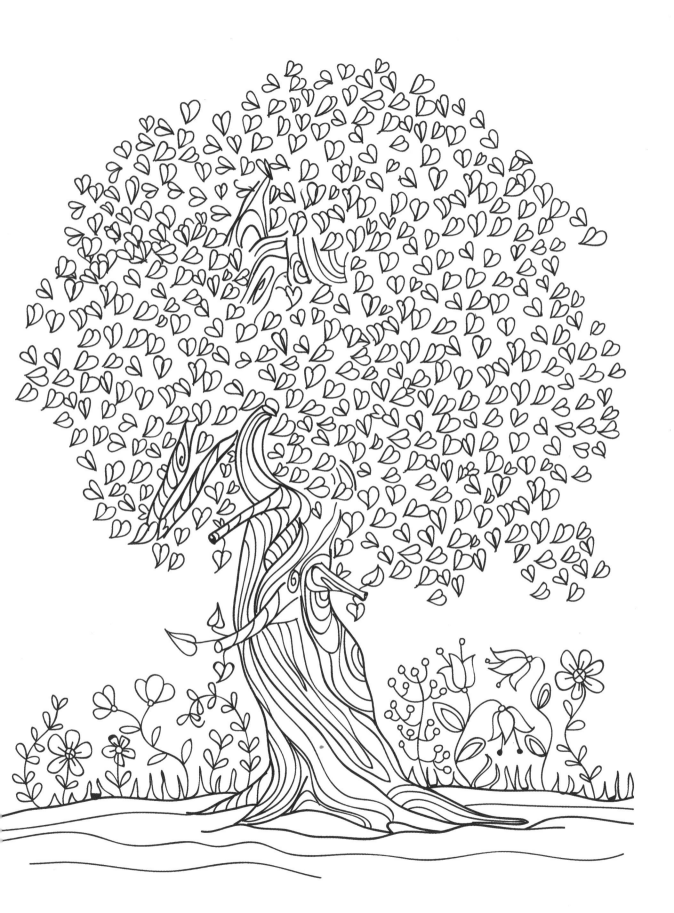

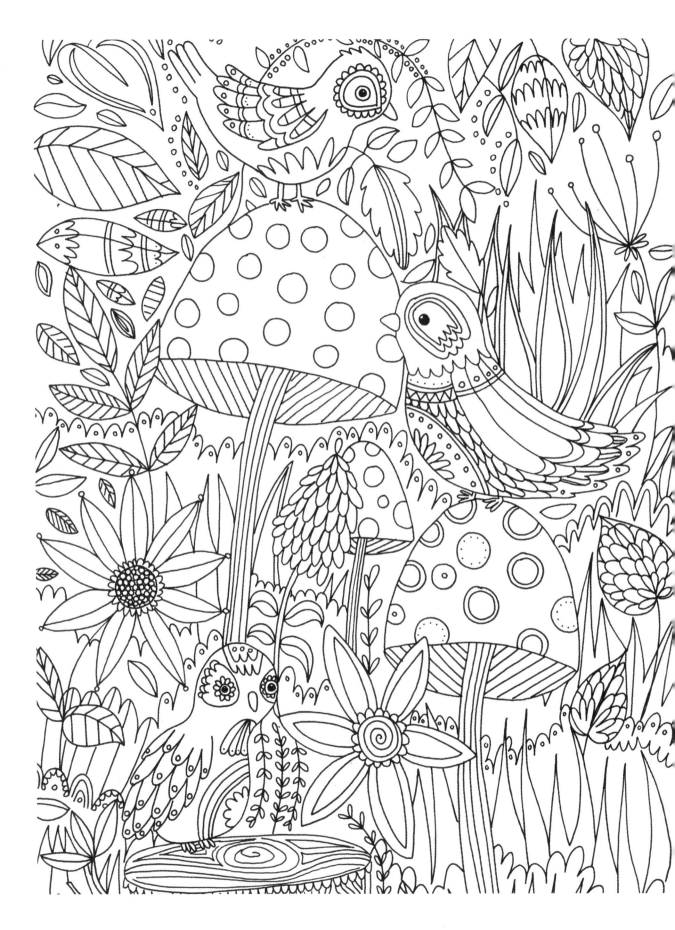

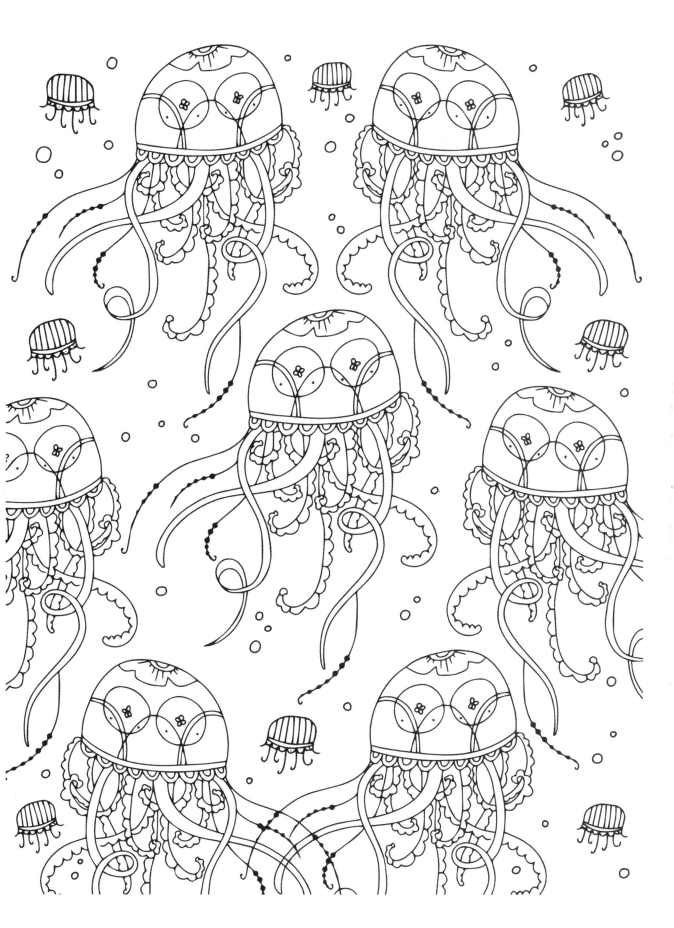

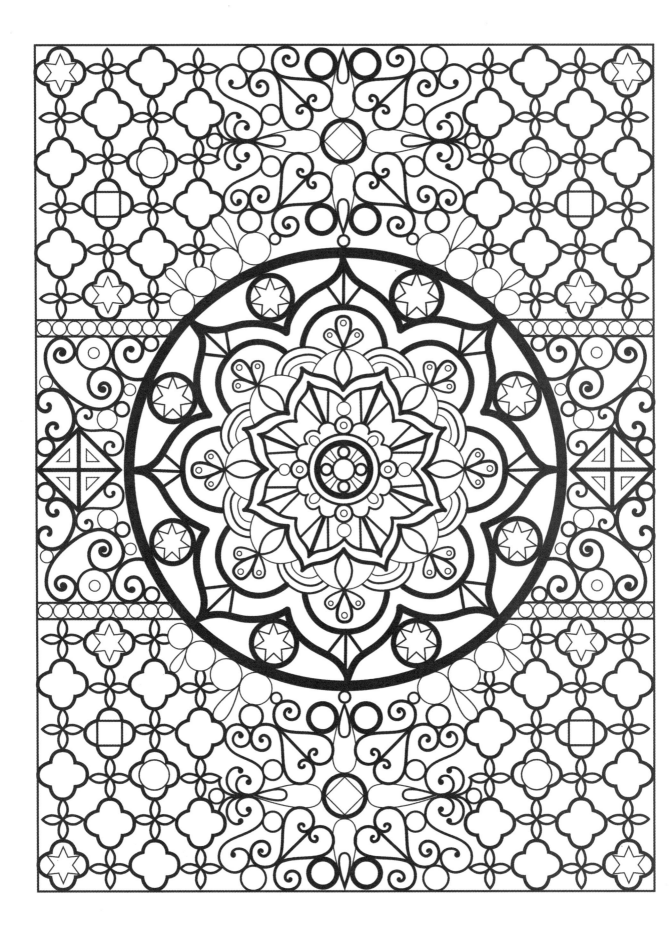

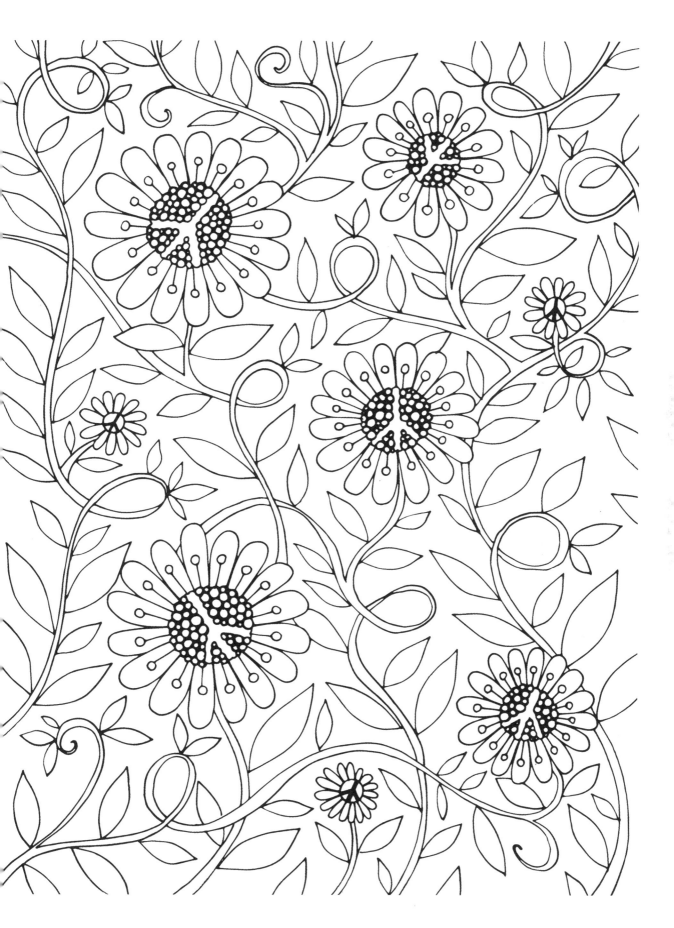

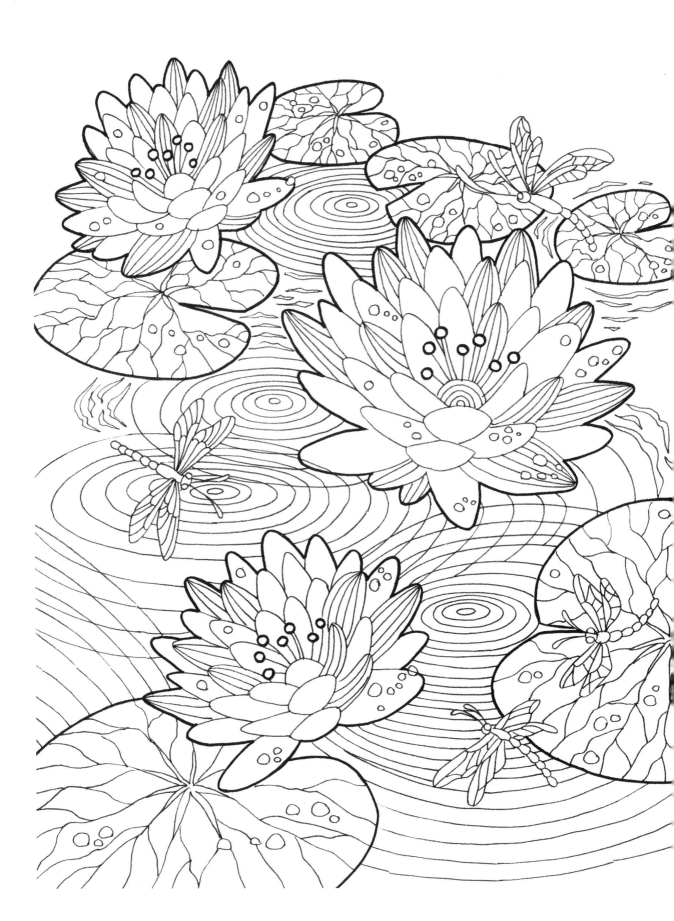

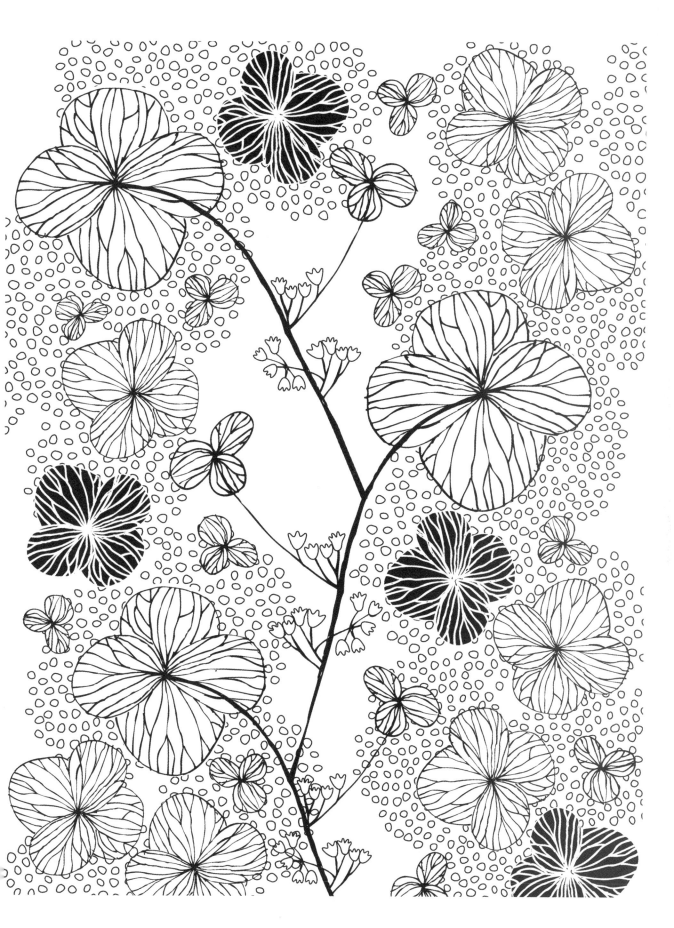

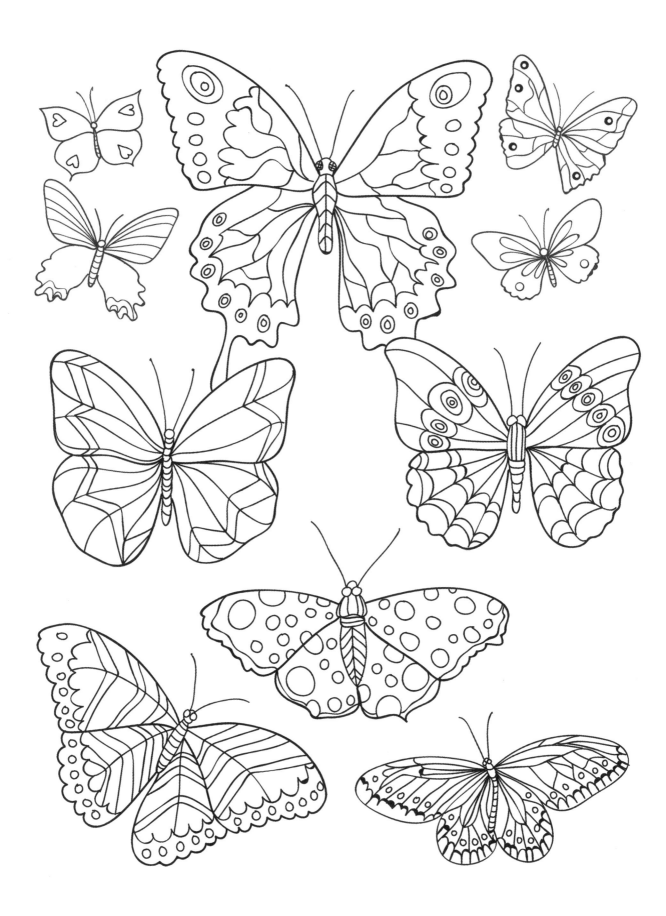

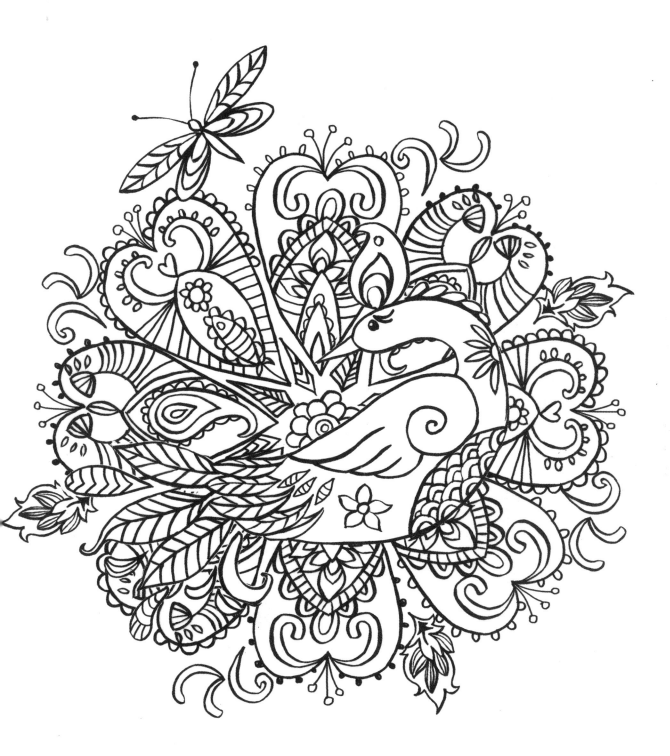

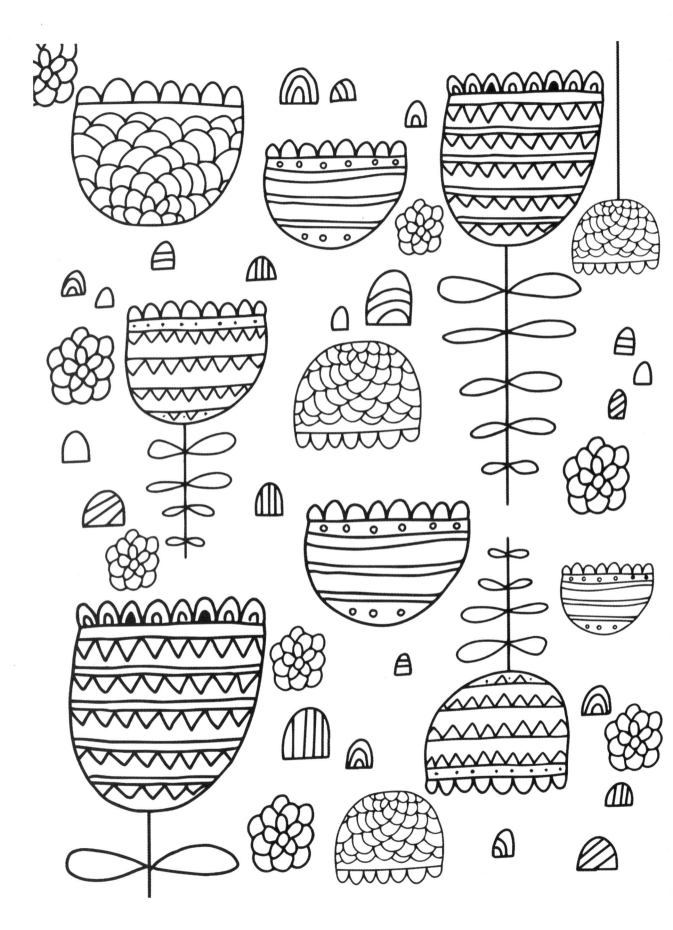

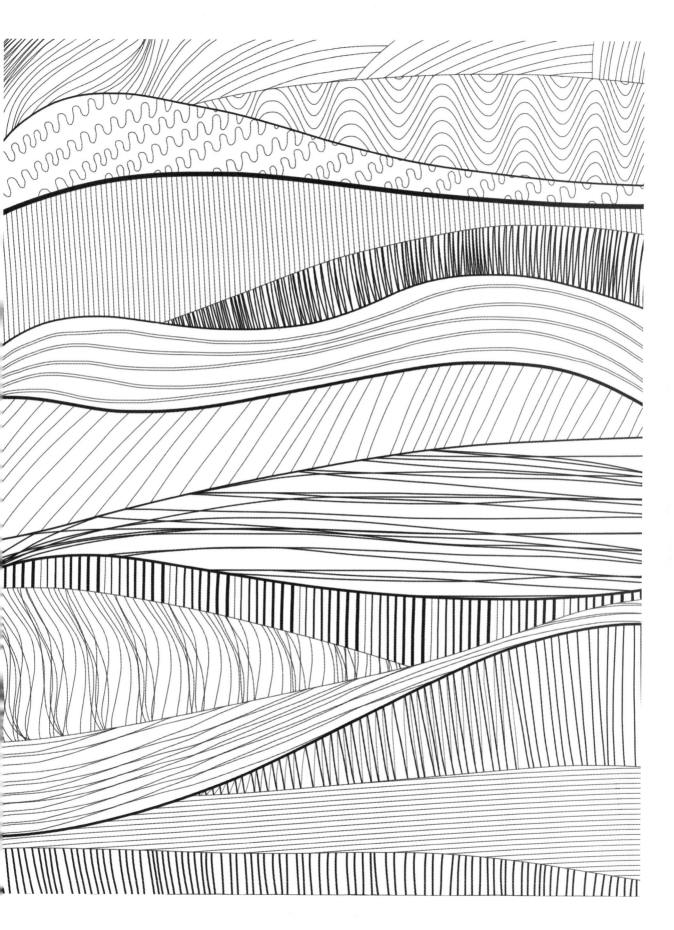

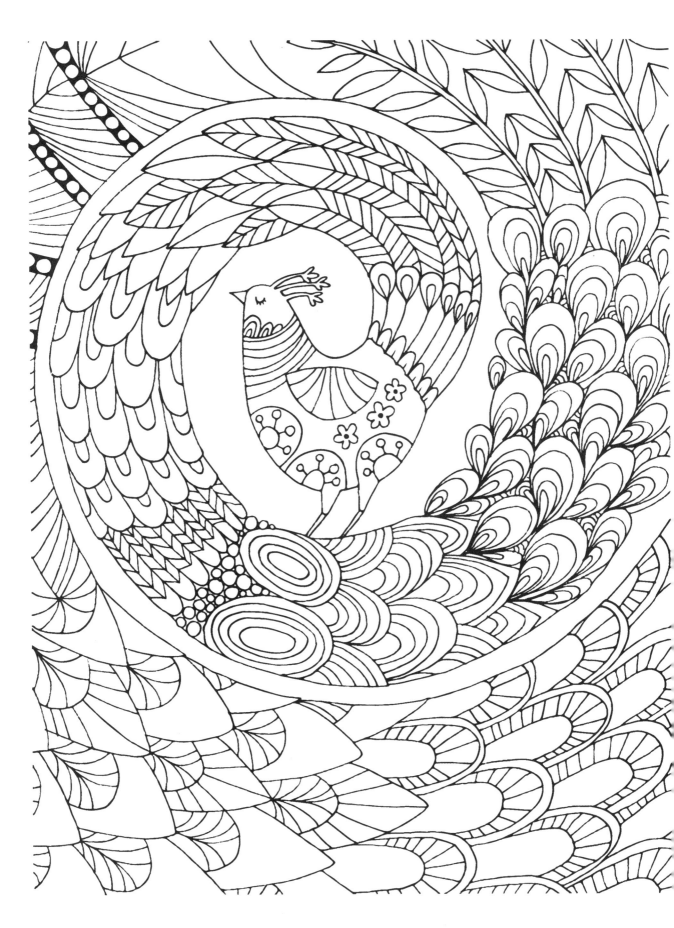

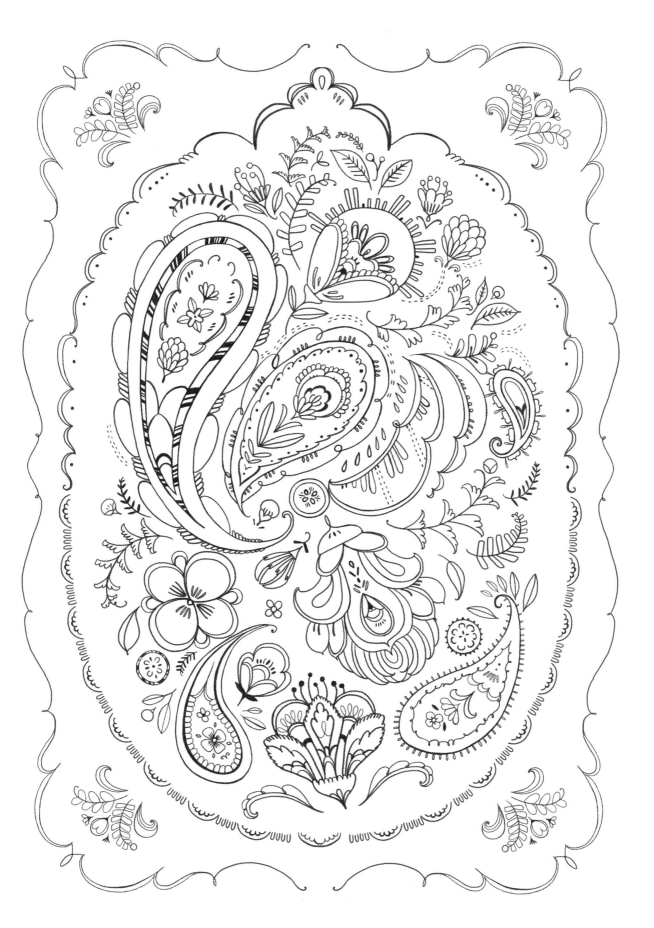

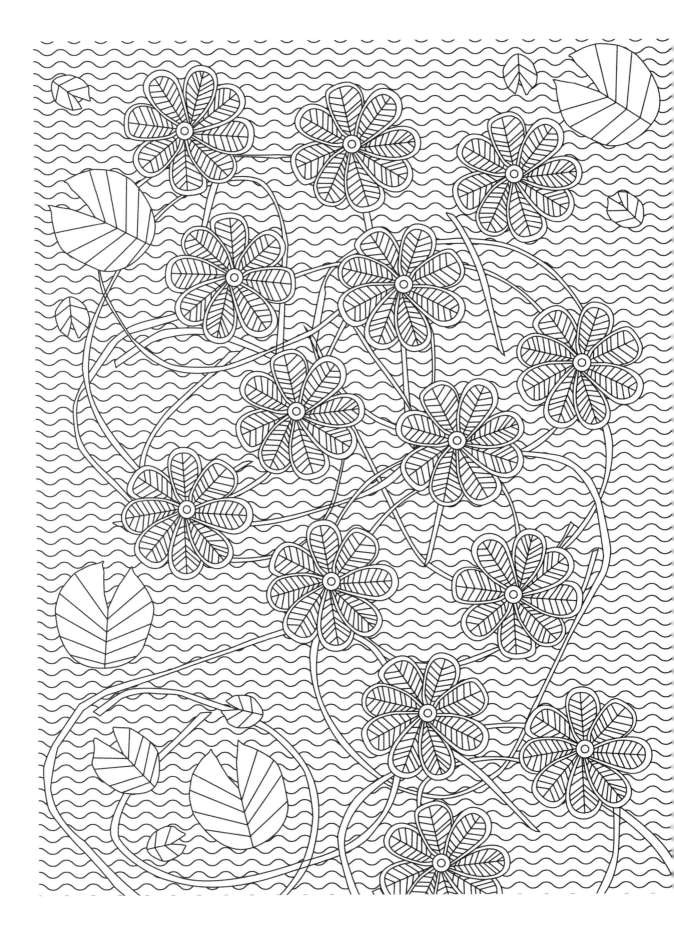

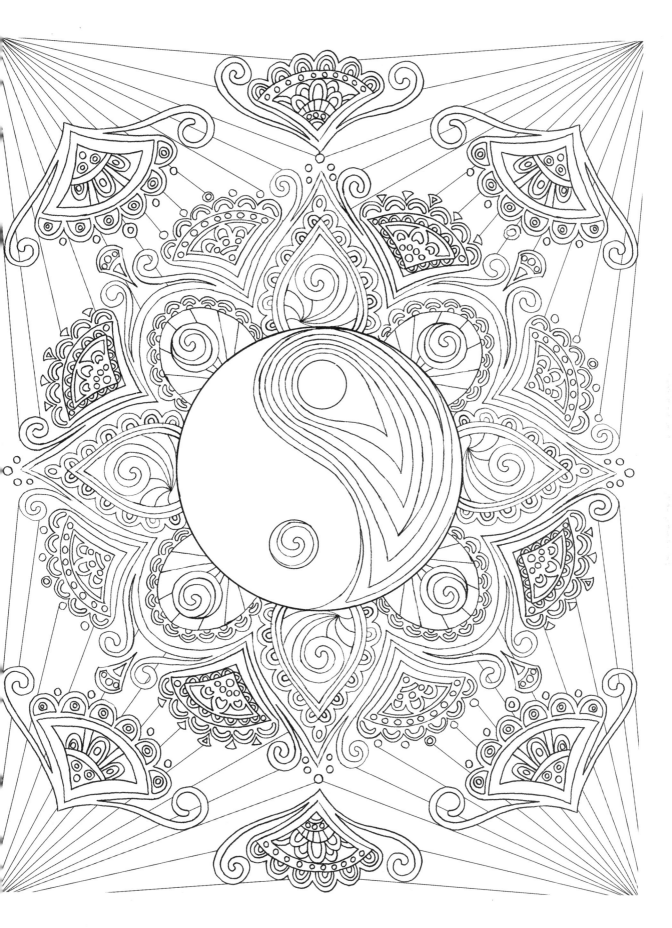

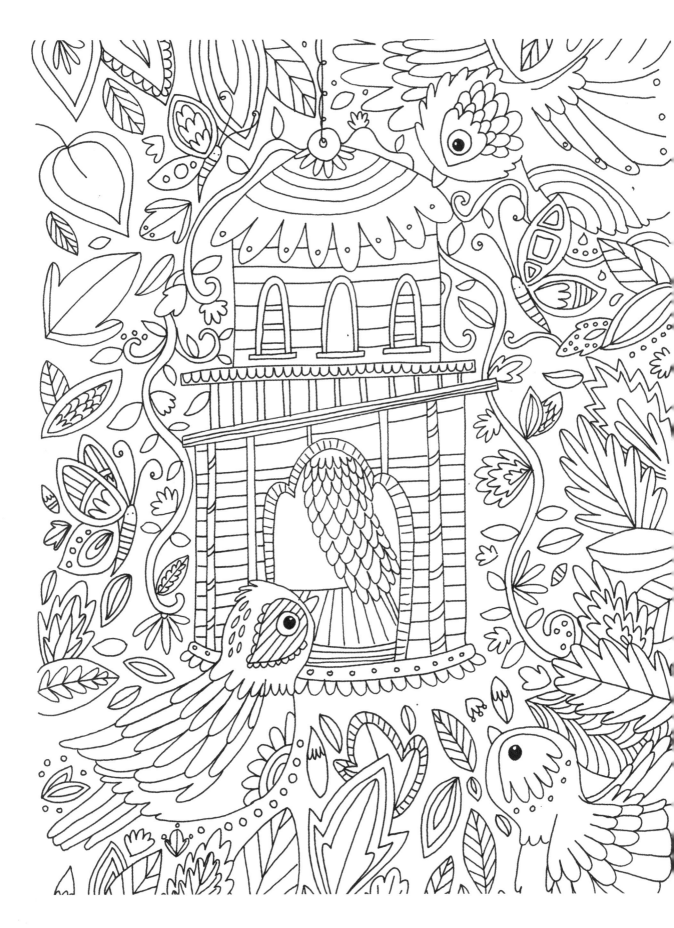

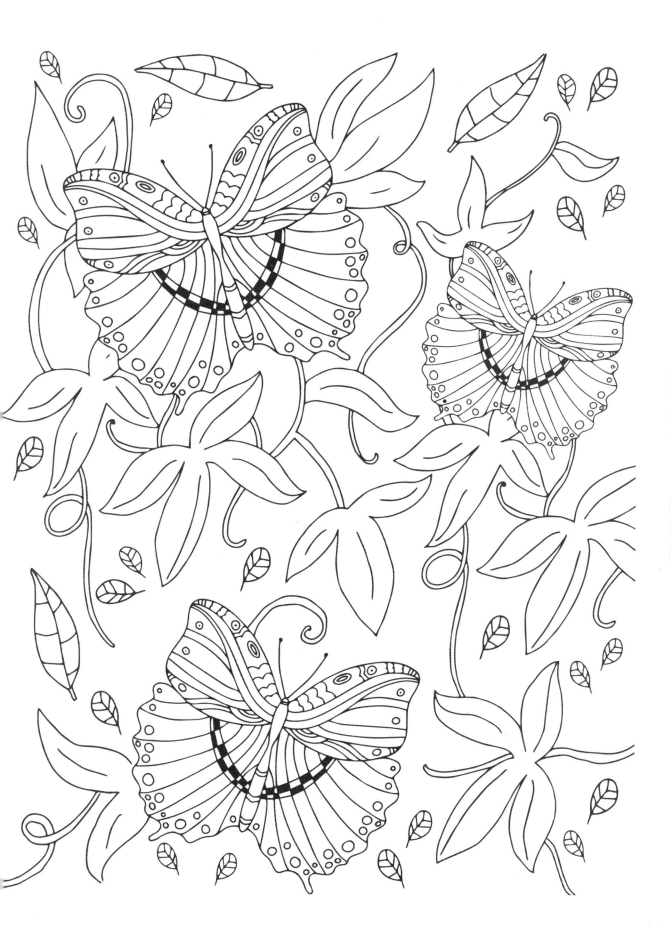

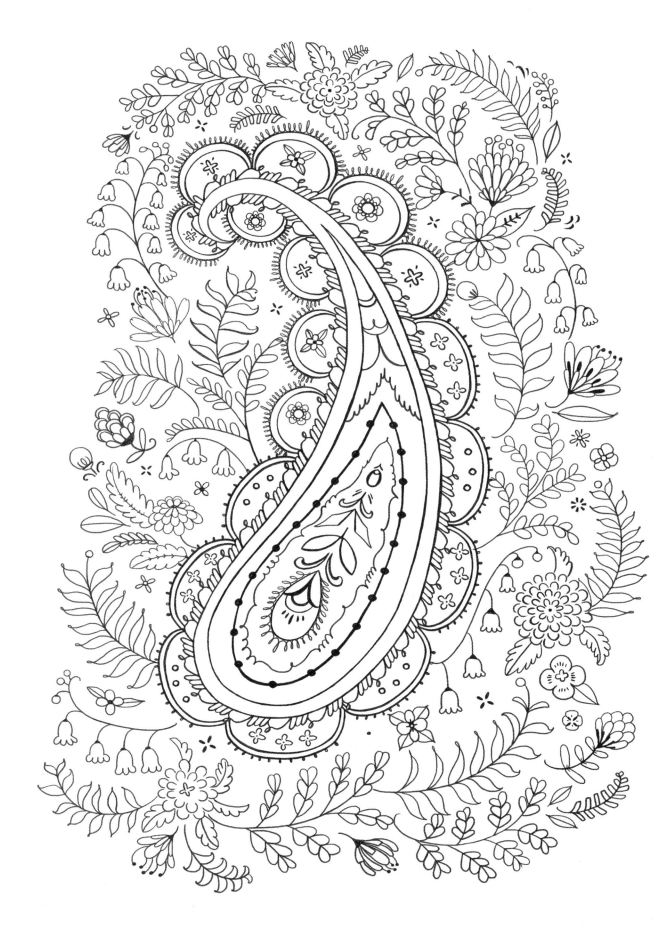

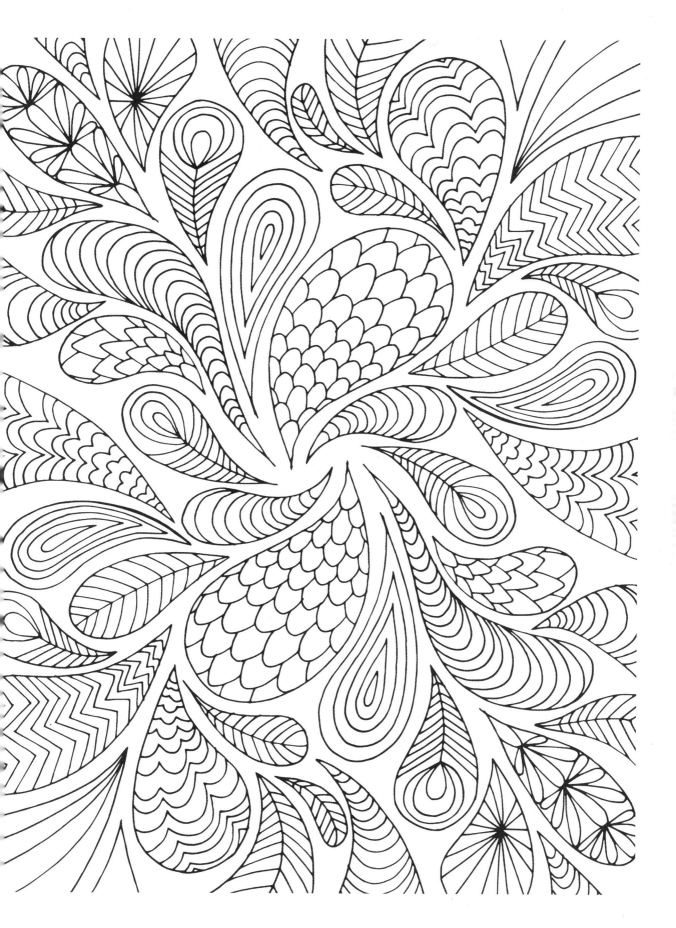

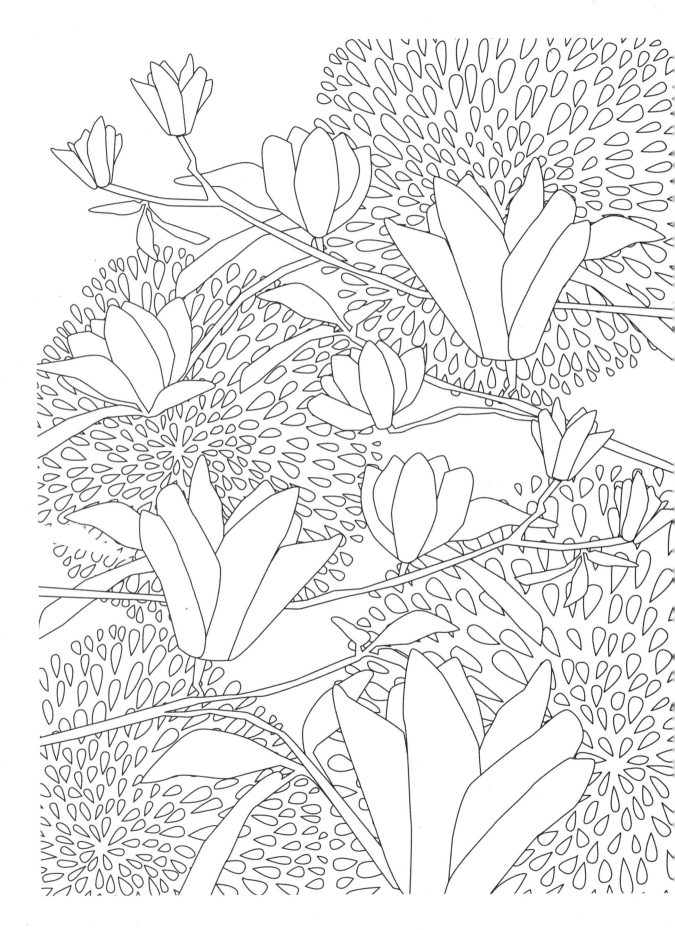